LETTERCRAFT

IN PRINCIPIO ERAT VERBVM ET VERBVM ERAT APVD DEVM ET DEVS ERAT VERBVM

Classical lettering cut in wood by Jost Hochuli

LETTER-CRAFT

incorporating

THE CRAFT OF LETTERING

THE CRAFT OF THE PEN

THE CRAFT OF SCRIPT

and a few words About Handwriting

JOHN R. BIGGS

BLANDFORD PRESS
Poole Dorset

First published in the UK 1982 by Blandford Press,
Link House, West Street, Poole, Dorset, BH15 1LL.

Distributed in the United States by
Sterling Publishing Co., Inc.,
2 Park Avenue, New York, N.Y. 10016.

ISBN 0 7137 1269 4

Printed by Trade Litho Book Printers, Bodmin, Cornwall

This book brings together three books, published separately, into one volume with the addition, at the publisher's request, of a short essay about handwriting. Over the years these little books have proved helpful to many people in a variety of countries, and in some instances second-hand copies have been sold at many times the published price. It is hoped that the three books, now under one cover, will be even more useful with the added material about handwriting and the important inscriptions by three of our finest monumental letter cutters, as well as woodcuts by distinguished Dutch and Swiss artists.

CONTENTS

SENATVSPOPVL

MPCAESARIDIV

TRAIANOAVGG

MAXIMOTRIBPO

ADDECLARANDVM

MONSETLOCVSTAN

13A

The CRAFTo

SQVEROMANVS
NERVAEFNERVAE
MDACICOPONTII
VIIIMPVICOSVIPI
VANTAEALTITVDINIS
IBVSSITEGESTVS

LETTERING

HERE
REST THE MORTAL
REMAINS ⏣ ABBOTS
FROM 1077 To 1401
· PAUL OF CAEN ·
RICHARD d'ALBINI
GEoFFREY ⏣ GoRRoN
· RALPH GUBION ·
ROBERT of GORRON
· SIMON ·
WARIN ⏣ CAMBRIDGE
· JOHN de CELLA ·
WILLIAM
OF TRUMPINGToN
JOHN ⏣ HERTFORD
JOHN de la MOOTE

And also of
RoBERT of the CHAMBeR
father of Pope Adrian IV
ADAM THE CELLARER
Prior ADaM WITTeNHAM
ADAM ROUS
Surgeon to Edward III

REMOVED in 1978 from
The CHAPTER HOUSE

SEEK FIRST
THE KINGDOM OF
GOD

Inscription in St Albans Abbey, designed and drawn out by David Kindersley, CBE, and cut by Lida Lopez Cardoza on Welsh slate 10ft 6in. by 3ft. As the inscription can only be read from the foot, letters (apart from the big ones) increase by 1mm in height and by 0.5mm in the space between the lines towards the top. This counteracts the tendency for letters to appear smaller the further they are from the eye.

THE CRAFT OF
LETTERING

AN alternative title to this section might well be 'An Approach to the Roman Letter'. The Roman letter (that is, the form of letter used by the Romans at the height of their greatness) is the source from which all the letters based on the Latin alphabet we use today are derived. Basically, then, this section is an introduction to the study and practice of the forms of the Latin alphabet.

But what is an alphabet? An alphabet is a series of arbitrary signs, shapes or symbols representing the sounds of speech. There are many alphabets and perhaps the three most important are the Latin, Arabic and Cyrillic alphabets, but we are concerned here only with the Latin.

Most forms of writing seem to begin with simple pictures of the things represented. These are known as pictograms. In the course of time the forms became more and more simplified so that it is often difficult to see the original picture in the ultimate symbol. Abstract ideas which could not be represented pictorially were identified by arbitrary shapes and are known as ideograms. Eventually it was discovered that it was practicable and more efficient to have signs representing the sounds of speech (phonograms) and so an alphabet was evolved.

The Romans, ever a practical and efficient race, were producing fine lettering some centuries before Christ, but by the second century A.D. the tradition of good craftsmanship in lettering reached a peak that may have been equalled but never excelled. Of the many fine examples of lettering produced at this time by far the most famous is the inscription at the foot of Trajan's Column which is reproduced in the title opening of this section. Without doubt this is one of the finest inscriptions ever carried out in incised classical Roman letter forms. As such, it has been admired and held as a model for craftsmen to emulate for centuries, but it must be remembered that this letter was cut with a V section (page 10) in marble and placed in a situation where strong sunlight would produce high lights and strong shadows which naturally influence the apparent shape of each individual letter and the general effect of the inscription as a whole. This in part accounts for the fact that painted versions of Trajan lettering —even when drawn over photographs—are usually disappointing when compared with the original.

The original inscription is about nine feet long by three feet nine inches high, and is on the pedestal at the foot of the column which rises to a height of one hundred and forty-seven feet. A spiral band of bas-relief carvings illustrating the Dacian wars, winds from the bottom to the top of the column which was surmounted by a statue of Trajan holding a gilt globe, afterwards replaced by a statue of St Peter. A doorway cut into the pedestal at some later date led to the lamentable triangular gash that disfigures the bottom centre of the inscription.

A possible translation is given which can readily be seen to be difficult and awkward in English, not only because of the Latin, but because it is not clear what the last part means. A gloss may help.*

It appears that Trajan wanted to build a new Forum, and to do

*Incised letter
V section*

* The previous Emperor (Nerva) adopted Trajan as his son. DIVUS is difficult, because there was a conception of Godhead with the Emperors. AUGUSTUS was a title of Honour, as were GERMANICUS for his conquests over the Germans and DACICUS for his conquest over the Dacians. PONTIFEX MAXIMUS was a religious office. This is heavy in English but sufficiently clear.

this he had to cut back the shoulders of two hills. The height of the excavation into the hillside was about one hundred and twenty-eight feet so that the column itself would give an idea of the amount of earth which had to be removed. It was completed in Rome and dedicated about A.D. 113. The letters in brackets complete the words that are given in abbreviated form in the inscription.

SENATUS POPULUSQUE ROMANUS
IMP(ERATORI) CAESARI, DIVI NERVAE F(ILIUS) NERVAE
TRAIANO AUG(USTO) GERM (ANICO) DACICO, PONTIF(ICI)
MAXIMO, TRIB(UNICIA) POT(ESTATE) XVII, IMP(ERATOR) VI,
CONS(UL) VI, P(ATER) P(ATRIAE),
AD DECLARANDUM QUANTAE ALTITUDINIS
MONS ET LOCUS TANTIS OPERIBUS SIT EGESTUS

Here is the translation.

THE SENATE AND ROMAN PEOPLE (HAVE DEDICATED THIS) TO THE EMPEROR CAESAR NERVA TRAIANUS AUGUSTUS GERMANICUS DACICUS, SON OF DEIFIED NERVA, PONTIFEX MAXIMUS, WITH TRIBUNICIAN POWER FOR THE SEVENTEENTH YEAR, EMPEROR FOR THE SIXTH YEAR, CONSUL FOR THE SIXTH YEAR, FATHER OF HIS COUNTRY—TO INDICATE TO WHAT HEIGHT THE HILL AND SITE WAS CLEARED FOR SUCH MIGHTY WORKS.

When studying reproductions of this superb example of lettering art and craftsmanship, it should be remembered that the original letters are enormously larger than reproductions in handbooks are likely to be. The six lines of the inscription vary in height from four and a half inches in the top line to three and seven-eighths in the bottom line. This progressive reduction in height of the letters counteracts the apparent reduction in size of the lines furthest from the observer's eyes namely the top lines, because the inscription is placed a number of feet above eye-level and therefore the bottom line will be appreciably nearer to the eye than the top.

The name of the artist or craftsman (or both) of this inscription is unknown. It cannot be said with certainty whether or not the same man drew and cut the letters. But it is probable that the

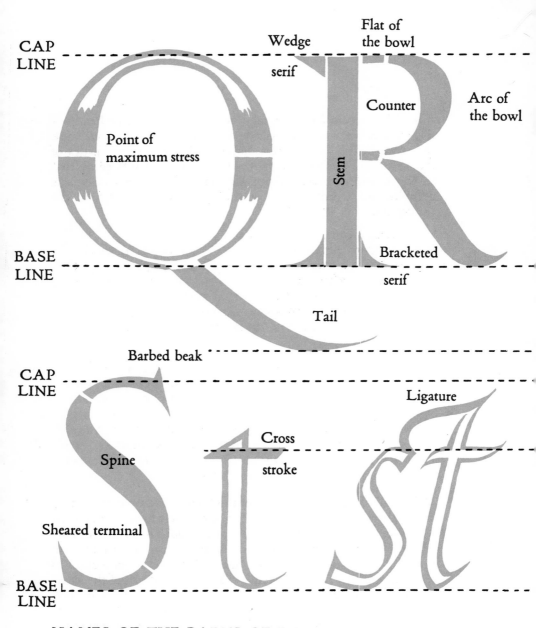

NAMES OF THE PARTS OF LETTERS

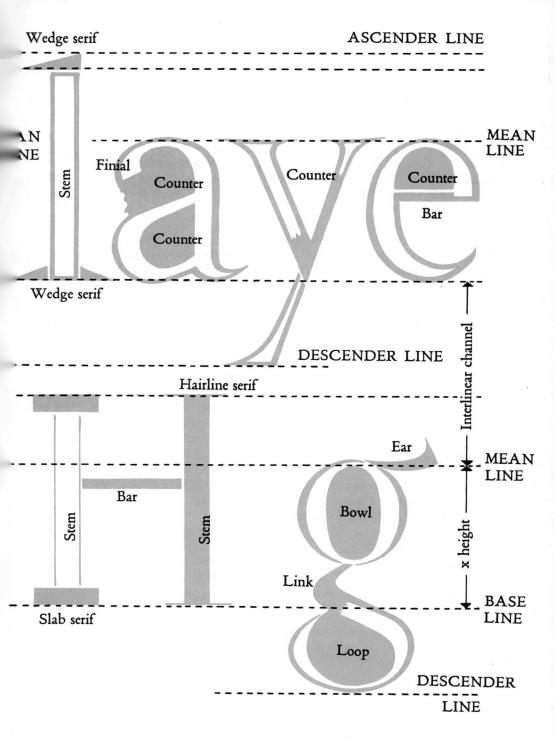

ASCENDER LINE

Wedge serif

MEAN LINE

Stem

Finial

Counter

Counter

Counter

Bar

Counter

Wedge serif

DESCENDER LINE

Interlinear channel

Hairline serif

Ear

MEAN LINE

Bar

Stem

Stem

Bowl

x height

Link

BASE LINE

Slab serif

Loop

DESCENDER LINE

letters were designed *in situ* by a letter artist who wrote freely on the stone leaving the cutting of the letters to a craftsman. F. W. Goudy, the famous American letterer and type designer, said of Trajan lettering, 'The shapes and proportions are those of pen or brush drawn letters, but the *character* is that of the cutting tool used to produce them'.

The placing of the thicks and thins suggests the use of a brush, and the variations seen in the same letter as it recurs suggests a fair speed of execution and certainly indicates an aesthetic considera-tion of the influence letters have on their neighbours. Evidently, second-century Roman lettering craftsmen did not aim at an absolute and fixed standard of proportion of individual letters, but worked on the sounder principle of designing letters in relation to one another, that is, designing words, lines and groups of lines.

While Trajan capitals provide one of the best models for a student to emulate it should not be regarded as the sole criterion of Roman lettering. Good as it is, Trajan can be, and often is, misused. The form of letter which was right for cutting about four inches high in marble and to be seen in bright sunshine, is not necessarily the right letter to be made in chromium standing on pegs an inch away from a red brick wall, and more likely to be seen through the rain or fog, than in sunshine. As in all forms of design, fitness for purpose (or any other phrase by which this may be known) is a prime principle. Properly made letters have an abstract beauty in their own right apart from the ideas they may express or the emotions they may evoke.

The Roman letter, as we shall now consider it, consists not so much of one alphabet or series of symbols as of three, namely, what are known as capital letters, lower-case letters and italic letters. All three require, if not definition, at least explanation.

CAPITAL LETTERS (Majuscules)

By capital letters we mean the 'large' letters that are of uniform height, and which range at the top on what is called the 'cap line' and at the bottom on the 'base line' (see page 12). Here is an alphabet of 'capital' letters.

ABCDEFGHIJKLMNOPQRSTUVWXYZ.

Roman inscriptions were almost invariably in capitals (or caps as they are often called in letterer's and in typographer's jargon). Caps are composed more of straight lines than curves and many letters have verticals and horizontals which impart a squarish character to the alphabet as a whole. Indeed, they have been described as 'square' letters in contrast to the more rounded forms of the uncial letter (which there is not space to explain further here). Roman capitals are dignified, formal and architectural in character.

With the development of formal penmanship and the evolution of the letters we call lower case, capitals were referred to as majuscules, i.e. the major or large letters. Lower-case and italic letters evolved directly from capital letters. The forces or conditions which led to the changes of shape in letters are principally (1) The nature of the tool or instrument with which the letter is made. For example, a pointed brush will tend to make shapes different from those that come readily from a chisel-edged pen. (2) The material or surface the letter is made in or on. Clearly, letters cut in a coarse stone or wood will have a different character from those painted on glass, engraved in metal or written on vellum. (3) The speed at which the letter is made. (4) The artistic fashion or mood of the age. (5) The size, scale and situation of the letters.

LOWER-CASE LETTERS

By lower-case letters we mean the letters of irregular height, some of which are contained between the base line and the mean line (see page 12), others rise to the ascender line, others fall to the descender line. Here is an alphabet of lower-case letters.

abcdefghijklmnopqrstuvwxyz.

Renaissance scribes referred to them as minuscules—the minor or smaller letters—in contrast to the majuscules (caps). The term 'lower-case' has grown up from a custom with printers in the past, to put the minuscule types in the lower of a pair of cases, the upper of which contained the caps. For the same reason caps are often referred to by printers as 'upper case'. Lower-case letters are much freer and less formal than capitals. They are less square in

Keep the hairs of the brush parallel
to the line being made

character. If capitals are thought of as letters in formal evening dress, lower-case might be thought of as letters in lounge suits for more everyday use.

ITALIC LETTERS

Italic is the term applied to the letters that are usually sloped as in this alphabet

abcdefghijklmnopqrstuvwxyz.

It should be observed that only the minuscule italic is given because it is only in the minuscule or 'lower-case' italic that there is any real difference from the shapes of the upright (or Roman) capitals. What are often called Italic Caps are really sloped Roman Caps with no essential difference in shape. On the other hand the lower-case italic is often very different in shape from the Roman lower-case. For example *A* is an A slightly sloped whereas *a* is quite different from a.

The reader will no doubt have noted that the terminology of lettering is sometimes ambiguous, but the context in which a word is used will readily indicate the sense in which a particular word is intended. For example, the word Roman is used to describe the parent letter of the second century A.D., of which Trajan lettering is a supreme example. It is also used to describe the numerous derivative letters in contrast to Black Letter or Textura. Further, the word Roman is used to describe upright letters as distinct from sloping or italic letters. For example, THESE ARE ROMAN CAPITALS. This is Roman lower-case. *THESE ARE ITALIC CAPITALS. This is Italic lower-case.*

We have already said that it is the italic lower-case which is the distinctive alphabet and the chief characteristics are (1) the letters are narrower (or more condensed) than its companion Roman lower-case. (2) The general feeling is more flowing, informal, or cursive. It is nearer in spirit to ordinary good hand-writing than is Roman lower-case, and therefore lends itself to much freer, flourished and informal treatment than would be appropriate with either Roman caps or lower-case. The slope need be only very slight.

The word italic applied to sloped letters long ago because it was an Italian, Aldus Manutius at the end of the fifteenth century, who first produced this condensed sloping letter in type. Because this letter came from Italy it was known as Italic and the name remains even though the association with Italy is forgotten, just as 'Indian' or 'Chinese' ink is no longer thought of as being particularly Indian or Chinese.

Compare carefully the three versions of the Roman alphabet we are studying:

ABCDEFGHIJKLMNOPQRSTUVWXYZ
abcdefghijklmnopqrstuvwxyz
abcdefghijklmnopqrstuvwxyz

The forms of the capital letters are fundamentally the same as they were in the second century A.D., and a literate Roman of that period would have no difficulty in reading them, but it is doubtful whether he would recognise that the rounded double-decker a and the sloping somewhat oval shape *a* stood for the same vowel sound as the triangular A. In fact, there has been a logical but gradual transition from one to the other—from caps to lower-case, from lower-case to italic—and it is important for the letterer to realise how much is taken for granted and how readily we accept widely different shapes as representing the same sound of speech.

LEGIBILITY

Every reader will recognise each of the above forms instantly, and it is to be hoped that every reader will recognise just as readily that some forms are more legible and better than others. The goodness or rightness of a letter is obviously closely related to its legibility. But what do we mean by legibility? Many scientific or quasi-scientific experiments have been made to test the legibility of different letter forms but no conclusions have been reached which do not confirm the principles that have guided skilled letterers for centuries; and no discoveries have been made that had not already been made intuitively by letterers or revealed in the course of their experience.

The chief conclusion on the nature of legibility is that people tend to find most legible those forms which are most familiar.

That seems almost too obvious to be worth stating, but it is often overlooked by misguided letterers striving too hard and unnecessarily for 'originality'. Because we tend to read most easily the kind of letters with which we are most familiar, it does not mean that some letters are not more fundamentally legible than others. Two different letters should not be made so similar in shape that one may be mistaken for the other.

In a good alphabet, then, every letter should be sufficiently distinguished one from another so that there is no possibility of mistaken identity. At the same time letters should not be too dissimilar, indeed, a certain consistency and uniformity in some respects is an aid to identification. There should be a kind of family likeness in all the letters of an alphabet though each letter should retain its own individuality. It might be said that there is an underlying character, identity or distinctive individuality for every letter, no matter how it may be dressed up. Hence we might speak of the essential A-ness, B-ness or C-ness of those three letters, and so on through the twenty-six letters of our alphabet. So long as the essential character of a letter is not violated the subtle variations that can be made are almost infinite. By long, careful and loving study of good examples, the student will acquire a feeling for the underlying individuality of every letter.

Some people consider that this basic character of a letter is to be found in the san-serif version of the alphabet. The earliest known example of Latin lettering has no serifs, and there is a widespread vogue for sans serif letters today. In the examples of lettering for study (page 24 *et seq.*) we show the sans serif letter designed by Eric Gill about nineteen thirty. Gill sans, as it is called, is one of the most normal and least eccentric of sans-serif letters and therefore one of the best for a beginner to study.

There is no doubt that a well-designed sans is very legible and is particularly appropriate for road signs, notices, and other similar uses where the words displayed are not numerous; it is even tolerable in leaflets and pamphlets, and telephone directories, where one is not expected to read for any length of time, but it would be unbearable in a novel or any book where continuous reading is required.

*Note the angle here
compared with the
curve at the foot*

Another point of view is that the sans-serif letter compares with the skeleton of the human figure and that the flesh of thicks and thins and serifs are required to make the letter completely satisfactory. Certainly, the forms of the Roman letter that have been consistently admired by competent authorities for almost two thousand years are those which have some strokes thicker than others and which have serifs to terminate those strokes.

NOMENCLATURE OF LETTER FORMS

Letterers and students of lettering require words to describe accurately and briefly the different parts of letters so that discussion and comparison can be made without wordy explanations. On pages 12 and 13 is a diagram giving the names of the parts of a letter as used by the author, and which is based on the nomenclature suggested by Joseph Thorp and published by the Monotype Corporation. Most of the terms are self explanatory, and although one or two are not entirely satisfactory better ones are not available, and it seems wiser to stick to terms already in use and understood rather than introduce alternative words. Printers and type-founders use the term x height to describe the distance between base-line and mean-line. But this is apt to be confusing to the beginner because an x might be a capital X also. Nevertheless it is often useful to distinguish between two type faces or drawn letters that may have the same height of capital letter, but the lower-case of one of them might have a higher mean line making the lower-case letters appear larger. It would be described as having a greater x height. A very big difference in apparent size may be achieved by varying the position of the mean line. In both these examples the caps and ascenders are the same height but the higher mean line makes example (b) seem very much larger. Hence (b) has a greater x height than (a).

The term 'point of maximum stress' is useful to describe the point in curved letters where the stroke reaches its maximum thickness. This point may vary very considerably in its position in relation to the vertical. Sometimes, as in 'modern face' lettering (see page 67) the point of maximum stress may be exactly half way between the cap line and base line giving a vertical emphasis to the letter, and is often referred to as having a vertical stress. In

*Note the
curve here*

[19]

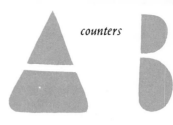

many classical alphabets the point of maximum stress is at about two o'clock and eight o'clock and may be described as diagonal stress. Another term employed for this same feature is shading; a letter may be said to have vertical or diagonal shading. The precise position of this point of maximum stress can have a great influence on the general character of a mass of lettering where the vertical or diagonal stress may be repeated many times, as in a page of a book.

The word counter applies to any of the internal shapes of letters, that is, those parts of the background that are completely or partly enclosed (page 12). Because the lower case g has two completely enclosed counters it is convenient to call the upper one the bowl and the lower one the loop. The loop can vary enormously in size and shape.

The counters are most important parts of letters and great attention should be paid to them, noting the slightest variation of curve, any tendency to straightness, or the presence of an angle. It is hardly too much to say that if the counters of a letter are carefully drawn the outside shapes will take care of themselves. A letter is not simply a series of strokes made upon a surface; the background shapes enclosed or indicated are just as much part of the letter as the strokes themselves and must be meticulously fashioned. It is good practice to make a few large letters by painting the background leaving the 'letter' untouched in order to encourage concentration on the precise shape of the counters. Perhaps better practice still is to cut a few letters in linoleum; here the counters and background are cut away and the letter is what is left behind.

Serifs are the strokes which project on either side of the ends of main strokes. Serifs may be as thin as a hair line as in modern face, or as thick as the stem as in slab-serif or Egyptian letter, or even thicker than the stem as in French Antique. They may be straight or curved, long or short, according to the designer's intention, which will (or should) be governed by the nature and purpose of the lettering. A brush can achieve long, finely pointed and very elegant serifs, and on some occasions such long serifs may be appropriate and good, but the beginner should beware of making serifs long or heavy—they are so easily overdone.

The serifs on stems as in cap I may be horizontal and straight but in freely painted lettering they are more often subtly curved with a faint suggestion of a fish tail. This, too, must be done with discretion: exaggerated curves and too obvious fish tails are objectionable.

As to the relationship of serifs to stems and strokes it is best to think of serifs as growing naturally out of the stem as a bud grows out of a branch. The appearance should be avoided of serifs looking as though they are pre-fabricated accessories attached to pre-fabricated stems. Serifs and stems, indeed the entire letter, should be thought of as one integral, homogeneous whole. The student's aim should be to draw (or paint) the serif and stem in one continuous uninterrupted sweep, not to add serifs to previously drawn stems.

Stems are the thick main strokes of a letter and their proportions are therefore very important. The boldness or weight of a letter is conditioned by the width of the stem in relation to its height (page 18). In Trajan lettering the stem is about nine or ten times as high as it is wide. Or, to put it in another way, the proportion of stem width to height is 1:9 or 1:10. Before copying any letter it is wise to estimate the number of times the stem width goes into the height—it is so easy to misjudge and to produce a letter that is too heavy or too light.

Generalisations, if not taken literally and due allowance made for exceptions, can be helpful. One such generalisation is that large sizes of letters require great refinement of form and shape because one is more likely to look at each letter individually and to examine the counters, the shape of the serifs and so on. Small sizes, on the other hand, while requiring just as much care and thought, are less likely to be scrutinised individually but rather to be looked at as a tone or texture. A general evenness of tone and texture is very important in small lettering. The rhythm of small letters as they combine into words and lines takes precedence over decorative qualities that tend to rank higher in large letters.

Good lettering means not only the thoughtful delineation of each individual letter but the meticulous placing and spacing of letters into words, and words into lines and groups of lines. Each word should have the appearance of every letter being the same

distance apart and of every word being the same distance apart. To achieve this *appearance* of even spacing curved letters like—DO —might almost touch, but when parallel thick strokes come next to one another it is necessary for them to be placed a little farther apart.

Some letters appear to have more 'background' than others. For example H, being bounded by stems on each side, has no back' ground to link up with an adjacent letter; on the other hand A appears to have two triangles of 'background' that are liable to attach themselves to the 'background' of its neighbours. The letters that have such large amounts of 'background' A, L, P, R, T, V, W, Y, make spacing hazardous, particularly if they occur in a context which also includes many parallel stems and there is little room to accommodate them. The spacing of a word or line of words is conditioned by the spacing imposed by the juxta' position of one or two of these letters. If L is followed by A, steps must be taken to avoid the appearance of a gap as in LADLE. In type one would have to accept the amount of space between LA and increase the amounts of space between the other letters until evenness is arrived at. In freely drawn lettering it would be possible to reduce the length of the limb of the L, make the thin stroke of the A a trifle nearer vertical and perhaps extend the serif at the apex to help fill up the gap.

Every word (or group of words) brings its own problems of spacing because of the variety of shapes and amounts of 'back' ground' resulting from the association of the various letters. The letterer must learn from experience how to deal with each com' bination of letters as it arises. Sometimes proper spacing may be achieved by accepting the widest 'natural' spacing, and spacing the rest of the letters accordingly. At other times the proportions of the letters themselves must be modified to suit the occasion.

It has long been the custom to relate the proportions of Roman capitals to a square and therefore each letter has been printed on a square, each on a separate page, which we trust will help the student to accustom his eye to the relative widths of the letters. Some letters are obviously wider than others and it is helpful in the study of capitals to put them in groups of approximately the same width. Edward Johnston, the eminent calligrapher, divided

the alphabet into two main groups which he subdivided as follows:

(1) WIDE: 'Round'—O, Q, C, G, D.
 'Square'—M, W, H, (U), A, N, V, T, (Z).

(2) NARROW: B, E, F, R, S, Y, (X); I, J; K, L, P.

Eric Gill thought it convenient to divide the alphabet into four groups: viz. wide, medium, narrow and miscellaneous.

(1) WIDE: O, C, D, G, Q. This group contains all the round letters.

(2) MEDIUM: H, A, N, T, U, V, X, Y, Z, also W and M. This group includes all symmetrical letters.

(3) NARROW: E, B, F, L, P, R, S. This group contains the non-symmetrical letters.

(4) MISCELLANEOUS: I, J, K.

Although these two great experts differed as to their classification they agreed in their practice which demonstrated that there are no rigid geometric or mathematical rules governing the proportions of letters. The widths of letters may be varied slightly according to the occasion of their use, and either of the above groupings may be used as a guide. It is surprising that Gill should have included W and M among the medium letters when in his own practice he almost always made the W and M as wide as, and even wider than, the O and certainly wider than the A, U or V.

The specimens on the succeeding pages are put forward as reasonable models for the beginner to follow, but he should also study books recommended in the bibliography, as many good examples of lettering as he can find and *practise,* PRACTISE, PRACTISE. If possible obtain the criticism of a good practitioner, and, if he will allow you, watch him at work. It is a great joy as well as a profound lesson to see a first-class letterer swing his brush in direct, confident sweeps.

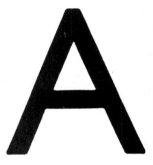

 (2)

 (1)

 (3)

 (4)

 (5)

A is a medium to wide letter. It is derived from the first letter of the Greek alphabet, *alpha*, which in turn came from the Phoenician *aleph*. Alpha combined with *beta*, the second letter of the Greek alphabet, gives us the word alphabet.

The cross stroke is usually about half-way between the cap line and base line: sometimes a little above, sometimes a little below. If it is placed too high the triangular counter becomes uncomfortably small and in small sizes of type is apt to fill in with ink. Though normally horizontal it occasionally inclines upward very slightly from left to right.

The apex in inscriptional forms is frequently pointed, as in (1), but there are many examples, even in classical Rome, of the apex being sheared horizontally as in (3) or at an angle as in (2). Brush forms usually have a generous serif which may even extend into an exuberant curve when the occasion is appropriate (4). The relationship of the thin stroke and the stem where they meet at the apex is shown in (5).

Serifs at the feet may be extended slightly on the outside of the letter but should be unobtrusive where they project into the lower counter. As in all the stems of a freely drawn Roman alphabet, the stem of the A does not have parallel sides, rather do they curve inwards slightly to produce a scarcely perceptible 'waist'.

B is also *Beta* the second letter of the Greek alphabet. It is a narrow letter and, if made too wide, is apt to look bloated.

Properly designed, B is one of the most beautiful letters of the alphabet and possesses a number of subtle and interesting features. The stem is not only faintly 'waisted' but is often slightly thicker towards the bottom than the top. The curve of the upper bowl springs from the stem at an angle in contrast to the lower bowl, which swings from the foot of the stem in a graceful curve. In consequence there is a conspicuous difference in shape between the upper and lower bowls as well as the inequality of size. The lower bowl is always the larger of the two.

The stroke which divides the two bowls is almost horizontal in its lower contour, but the upper contour (which is the boundary of the upper counter) often slopes up slightly as it joins the stem. It is obviously above the half-way line. Compare with R and P in which the bowl comes below the half-way line.

The point of maximum stress in the upper bowl is between one o'clock and two o'clock, and the curve descends and diminishes almost to a point as it meets the upper part of the lower bowl, which gives the appearance of having been made with a reed pen or brush starting horizontally at the stem before swinging downwards to the base line.

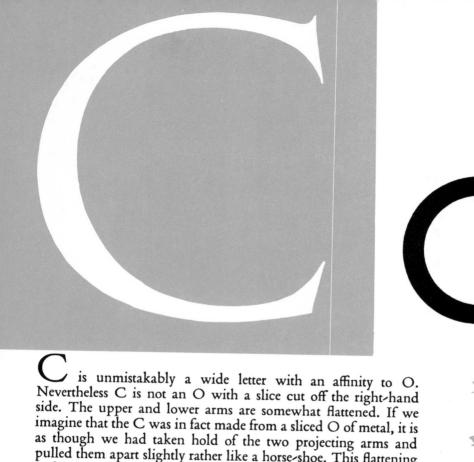

C is unmistakably a wide letter with an affinity to O. Nevertheless C is not an O with a slice cut off the right-hand side. The upper and lower arms are somewhat flattened. If we imagine that the C was in fact made from a sliced O of metal, it is as though we had taken hold of the two projecting arms and pulled them apart slightly rather like a horse-shoe. This flattening and its transition from point of maximum stress through the arm into the serif or terminal is very subtle. The terminal may be sheared vertically, have a barbed beak, or (in free brush forms), have an elusive curve reminiscent of the 'fish tail' at the head of the stem of the I. It is generally better to make the terminal of the upper arm a trifle more emphatic than the lower arm which may, indeed, end in a point.

The point of maximum stress in the Trajan letter is at about eight o'clock, but it may be higher according to the designer's feeling. If it is placed centrally in the C it should also be centrally placed in the O, D, G, Q, and similarly in other letters with bowls.

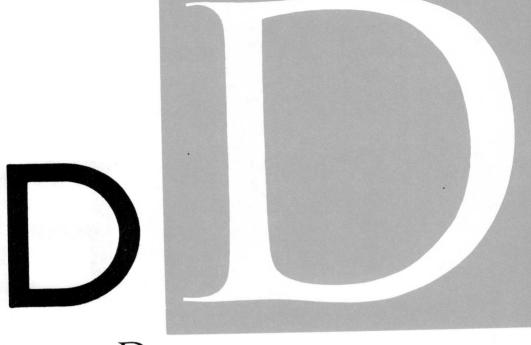

D is also a wide letter and is best kept so, but if the necessity arises D is capable of considerable condensation without greatly reducing its legibility.

As in the B, the stem thickens a little towards the bottom. There is an angle where the stroke swings away from the top of the stem and a curve as it rejoins the stem at the foot.

The point of maximum stress is at about two o'clock, and, as in all the other curved letters in the Trajan inscription, suggests the use of a pen or brush. The shading in the Trajan alphabet occurs just where a pen or brush would naturally place it, whereas there is no such 'natural' placing of thicks and thins with the chisel.

D was triangular in the classic Greek form and was named *delta*. The triangular connotation of the word delta is also seen in the delta of a river and in deltoid, the name of the triangular-shaped muscle at the top of the arm.

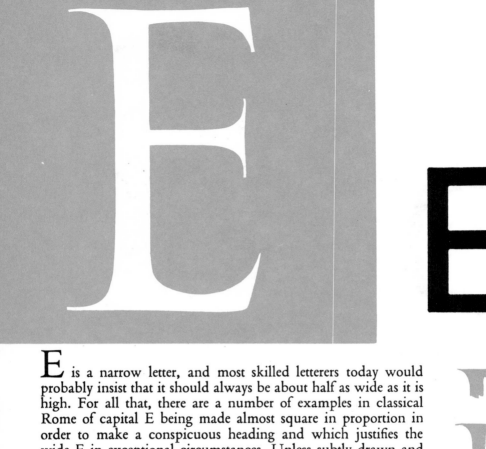

E is a narrow letter, and most skilled letterers today would probably insist that it should always be about half as wide as it is high. For all that, there are a number of examples in classical Rome of capital E being made almost square in proportion in order to make a conspicuous heading and which justifies the wide E in exceptional circumstances. Unless subtly drawn and proportioned the wide E is liable to be vulgar and objectionable.

The upper arm joins the stem at an angle while the lowest arm is attached to the stem by means of a curve or bracket. The bottom arm often extends beyond the upper two and sometimes ends in a minor flourish instead of the more orthodox serif or sheared terminal. The middle arm is just above the half-way line. A handy rule of thumb (though rules of thumb should be used with caution) is to make the half-way line the lower contour of the middle arm. It is generally best made about the same length as the upper arm.

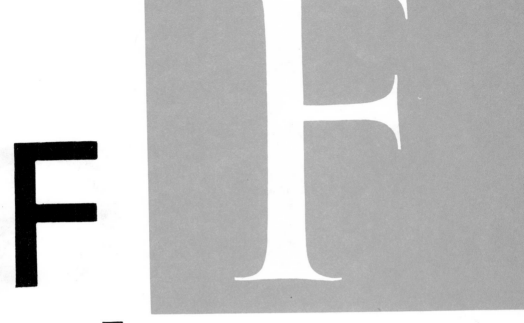

F is also a narrow letter and may be regarded as an E minus the bottom limb. Also like the E, the stem swells slightly towards the bottom.

The upper arm joins the stem at an angle. The centre arm is about the same length or a little shorter than the upper arm. The arms or thin strokes (as in other similar letters) are about half as thick as the stems.

G is a wide letter that resembles the C. It was introduced by the Romans who originally used the letter C for the sounds of both K and G. (The use of one letter for different sounds is still with us. In the word *cake* the c indicates the same sound as the letter k in king; in the word *civil* the c represents the same sound as s in silly.)

Like the C, the arm at the top is flattened and the terminal may be sheared or given a freely drawn 'beaked' serif. Again restraint is likely to produce better forms than rash exuberance. It should be in line with the right-hand side of the stem.

The short stem that rises from the lower arm may vary greatly in height. If it is too long it may, from a distance, appear to link up with the upper arm and look uncomfortably like an O. If it is too short it looks mean and niggardly and not sufficiently differentiated from C. In the counter there is often an angle where the stem rises from the lower arm (1, x), but frequently there is a curve. Both forms can be satisfactory. On occasions the stem may descend below the base line and even finish with a gay flourish.

Another but unusual feature is to see the lower arm, apparently projecting slightly beyond the stem producing a sort of spur at the right-hand base of the stem (2).

H is a medium to wide letter which is made up of two Is connected by a cross-bar of about half the thickness of the stem.

The cross-bar may be slightly 'waisted', that is the middle of the bar made a little thinner than the ends where they join the stems; hence the two edges of the bar are not straight but gently curving. Because of the bareness of this formal symmetrical letter the cross-bar has sometimes been given a little kink in the middle (1), but the beginner is not recommended to indulge in these frivolities.

The H is absent from the Trajan inscription, but it is present in other second century Roman inscriptions, sometimes in a different form. The upper half of the right-hand stem was sometimes omitted. When this form was written freely or quickly the cross-bar tended to curve down into the shortened right-hand stem, thus anticipating the development of the lower-case h.

Another ancient variant, no longer used, is for the left-hand stem to project above the cap line.

(1)

[31]

I is a simple and seemingly insignificant letter. In fact it is the letter that sets the standard of height and breadth of stem for the whole alphabet and as such should be designed fastidiously. The Romans often extended the I above the line to indicate the long vowel as in the word DIVOS. A dot did not appear over the I until about A.D. 500. It is good to practise the I assiduously to achieve the smooth continuity of contour from serif to stem.

J is a letter which was not used by the early Romans and therefore does not appear in their inscriptions, but it came into occasional use in the second century for the consonant Y and the vowel I. It was not until the seventeenth century that J was established to represent its present consonant sound. In form it is an I carried below the base line, and may taper to a point or swing to an abrupt finish in a sheared terminal. In the nineteenth and twentieth centuries it sometimes ended in a circular blob. In 'modern face' letters the tail of the J does not descend below the line.

K is a widish letter. It is another letter that does not appear in the Trajan inscription, but it is an ancient symbol which is still almost as it appeared on the Moabite stone in the ninth century B.C.

The main stem is an I and presents no difficulty. On the other hand the relationship of the diagonal strokes one with the other and with the stem needs great care and attention. The thick diagonal should neither overlap the stem as in (1) nor be attached to the thin diagonal some distance from the stem (2). The point of the angle obtained between the two diagonals (approximately a right angle) should just touch the contour of the stem about the half-way line. The thick diagonal or tail lends itself, like the tail of the R, to fanciful, frivolous, and even skittish treatment.

The tail may appropriately end with a curve tapering to a point (4), or firmly on the base line as (5), or even with a serif similar to the stem of A. Which of these forms it is best to use will depend on the circumstance of use, e.g. whether it is the first or last letter of a word; whether the letter following the K is a thick stroke as I in the word KING, or a thin diagonal as A in the word KAFIR. Within a word the tail is best kept shortish and not projecting beyond the serif of the upper arm. At the end of a word the tail may legitimately be extended.

not this

or this

)

)

)

4)

5)

L is an indisputably narrow letter. It is virtually an E whose two upper limbs have been amputated. The L's single limb is about half the stem's height but it may even be less, particularly if the L is unfortunately followed, as it so often is, by an A. Unless the limb of the L is kept as short as is consistent with legibility, the gap caused by the juxtaposition with A will disturb the spacing of the line. Because of the large amount of background contained in the letter above the limb L is notoriously difficult to space in words. The difficulty becomes even greater if the limb is lengthened. The exceptions are (*a*) when the L is followed by a T, as in CELT, and the limb can be tucked under the outspread arm of the T. (*b*) when it comes at the end of a word at the end of a line an extension or slight flourish might be acceptable. The end of the limb may be sheared as (1) or tapered as in (2).

(1)

(2)

M is one of the widest letters, occupying more than a square. In the Trajan inscription the two upper apexes are pointed and this tradition in incised lettering has led some letterers to be dogmatic and say that there *ought* to be points at the top—just as they are inclined to say there *ought* to be points at the top of A and N. A point is easy enough and natural enough to cut in stone with a chisel, but other forms come more naturally to the pen or brush. In consequence most printed and painted forms of M have flattened apexes that usually extend outwards in serifs.

An M may be thought of as a V with legs to support the overhanging limbs, and in which the parts of the serifs which normally project into the counter of the V have been sheared (1). The angle of the V may vary and the supporting limbs may be vertical or splayed a few degrees.

There are three counters in an M and unless the angle of the V portion and the angle of the splayed legs are carefully adjusted disaster may result. The need to keep these counters open and clear sets a limit to the amount an M may be condensed. Indeed, it is very difficult to condense an M very much without great loss in legibility and overwhelming loss in aesthetic quality.

The point at the bottom should just pierce the base line.

N is a medium to wide letter. Though capable of a fair amount of condensation without losing its identity, an N is more elegant and noble-looking if kept ample in width. The Trajan N has a pointed apex at the top and this pointed form is commonly seen in chisel-cut letters in wood and stone. On the other hand, pen, brush, and type forms more often have flattened apexes with a pointed serif protruding to the left and with an angle on the right (2). In due season this stem may be gaily extended up and over to the left; the left-hand vertical may also (in the right context) be continued downwards into a curve, a spiral or other flourish. The same applies to the right-hand vertical but the extension is upward not downward.

The thin strokes are rather thicker than in other letters and the thick stroke often bends down slightly as it meets the vertical at a point which just breaks across the base line.

(1)

(2)

(3)

(4)

O is clearly a wide letter, as broad as it is high, that is, for a good classical O. It should be understood throughout this book that where a certain feature or proportion is recommended to the student, no dogma is intended and with increased experience and, we hope, the development of good taste, many subtle variations are not merely permissible but desirable, so that there is a perfect harmony between the character of letter, the nature of the task in hand, and (dare we say it?) the personality of the designer. The latter should neither be obtrusive nor consciously pursued. Personal quality should be the outcome of the designer trying to do the job as thoroughly, honestly, and sincerely as he can.

The O sets the standard for all curved letters. The width of the thickest part of the strokes is slightly greater than the width of the stem of I and such like letters. This applies to all curved letters in order that the thick strokes of the curved letters should *appear* to be the same thickness as the stems. The thin strokes go slightly above and below the cap and base lines respectively. If they did not the O (and similar letters) would *appear* to be a little smaller than their companions.

The point of maximum stress may be placed centrally or turned to about one o'clock and seven o'clock.

P is a narrow letter. Superficially it resembles a B with the lower bowl erased. Close scrutiny of the bowl of the P will reveal that the curve does not follow quite the same direction as in the B, but swings lower, round to the left slightly, and begins to rise again a little. In the Trajan form the curve ends in a point on its faintly upward trend just before it reaches the stem. This open bowl can be very beautiful when well drawn, but most types and a large number of painted alphabets have closed bowls without any great detriment. The point at which the bowl is closed (or nearly so) is frequently just below the half-way line.

If the bowl is expanded to the right, the P will look bloated and top heavy in relation to the rest of the alphabet. For advertising there are alphabets in which every letter is expanded, that is, made wider than normal. But these are best left to the expert to design and to the skilled typographer to display.

1)

2) *rather than*

3)

4)

Q is a wide letter and everything said of the O applies to the Q. It is, in fact, an O with a tail on, but the length, placing and curvature of the tail demand taste and finesse.

In very early forms of Q the tail often descended vertically, sometimes from the right-hand side of the curve thus adumbrating the lower-case q. Later it became a short, straight stub descending diagonally to the right, which in time grew longer and more curved. The attachment of the tail to the main body of the letter calls for care. As Graily Hewitt said, 'It seems better to attach it boldly like a handle than to attempt the weaker smoothness of a tangent to the curve'.

Rarely, the tail has its source within the bowl cutting across the stroke in its descent to the right. Generally it is not good to do this, but there is precedent, even in Eric Gill, who produced some beautiful Qs with tails that begin within the bowl. He even made a decorative tail swing out to the left when the Q was an initial.

Because Q in English is always followed by U it is desirable to think of the two letters together. They generally look best if the U is the old form of V. The tail of the Q swinging under the rounded U is apt to produce an uncomfortable parallelism, but it can be avoided with a little ingenuity.

R Both Johnston and Gill classified R as a narrow letter, but it is more often seen as a medium-width letter. Goudy thought the R the most interesting of Trajan letters, certainly it is a very difficult letter to design and the Trajan R has most subtle details.

The bowl is neither the same size nor the same shape as the bowls of P or B, though it is nearer to that of the B than P. The lower contour of the thin stroke at the bottom of the bowl where it joins the stem is straight and horizontal, whereas the upper contour within the bowl curves up somewhat. The tail in the Trajan R springs from the bowl some distance from the stem. There are satisfactory forms in which the tail is attached to the extreme limit of the bowl and just touches the stem (1). The tail, as we said of the K, can taper to a point, curl like the front of a sleigh or the point of a Sultan's slipper, or finish discreetly in a serif.

 (1)

 (2)

(3)

 (4)

S

(1)

(2)

(3)

(4)

S is a narrow letter that many designers find formidable and intractable. A good proportion is for the width to be half the height—a little more or a little less according to circumstances. A too wide S is gross. The upper counter is a little smaller than the lower one, and the whole letter may lean slightly to the right if it comes before an A or follows a V (2).

The S is sometimes misleadingly grouped with a B or thought of as made of two O's one above the other. This often results in students making the unsightly mistake of producing a thin stroke in the middle with two points of maximum stress as in (1). The stress in an S is on the *diagonal*, not on an upper and lower curve. In other words, it is a *diagonal stress letter* having this common characteristic with A, K, M, N, R, V, W, X, and Y. The angle of the diagonal is best about 45 deg.

The serifs are best if vertical (2) or sloping outwards slightly (3), rarely sloping inwards. The upper serif should be vertically over the lower extremity of the curve but the lower serif may be a little to the left of the upper curve rather like a swan swimming. A reasonable order of strokes in constructing an S is shown in (4).

T is a medium to wide letter composed of an I with a horizontal member poised like a balance across its summit. This horizontal member can vary considerably in length without detriment to identity, and the two arms of which it is made up can be of unequal lengths. If it is the first letter of a line and is followed by W, the left arm may be lengthened and the right arm abbreviated. If the T comes at the end of a line the left arm may be shortened and the right arm extended.

The lower contour of the cross stroke may be one continuous curve and the upper contour may slope up slightly at both ends. For a gay occasion both arms may wave into a flourish, the right arm curling up and the left down (3).

Serifs may be parallel and diagonal (4), vertical (5), or the right may be vertical and the left diagonal (6).

(1

(2

(3

(4

(5

(6

(1)

(2)

(3)

U is a medium or wide letter. It does not occur on the Trajan inscription where the vowel was represented by V. The U is therefore a later invention to take on the work of the vowel, leaving V to stand for the consonant.

There are three distinct and satisfactory forms of U, any one of which may be best in a particular context. There is form (1), in which the left-hand stem curves up to meet the right stem a little above its base where the left-foot serif has been omitted. There is the symmetrical form (2) and the form (3) (more often seen in type) in which the left stroke is thick and the right thin as if it started as V and the apex was beaten out on an anvil into an almost semi-circular curve.

The curves, of course, come to just below the base line.

V is a medium to wide letter. In Latin inscriptions V stood for both the U and V sounds, as it did in English until the time of Shakespeare when V was given the name we now use for U; hence double U was represented by two V's VV. As late as the last quarter of the seventeenth century we find in books W made up of two V's though the compositor frequently filed off the right-hand serif of the first V so that the two would fit more snugly together and paved the way for the two letters to be made into the one character W.

The apex of the V projects below the base line.

The stem may, on appropriate occasion, curve up and over to the left in a brave flourish.

W is undoubtedly a wide and perhaps the widest letter of the alphabet. It does not occur in the Trajan inscription but was later made up of two V's (see under V).

There are many varieties of W in use today. There is the version which is virtually two Vs whose right and left serifs respectively overlap (1). There is the version composed of two wider Vs that cross over in the centre making four serifs on the cap line (2). Sometimes the two centre serifs are joined together by a horizontal line. There is the variant in which the centre serifs are eliminated and a pointed apex takes their place (3), and a further variety (4) which is similar to (2) but with the top half of the first thin stroke removed. Apexes go above and below the line as with other pointed letters.

X is a medium-width letter and a wide straddle should be avoided.

A seemingly simple letter, it is all too easy to get the angle of the two strokes wrong, with the result that the cross over of the strokes is too high or too low.

It is generally best to draw the thick stroke first. The counters need careful attention, particularly the upper and lower ones that open on to the cap line and base line. As with the A and the V, the serifs that project inwards should be modest, but the outer serifs may be more generous.

Y is a medium-width letter that should not spread its arms too wide. It does not occur in the Trajan inscription and is a letter used in words borrowed from the Greek. Y as we now use it is a variant of the vowel I.

The upper arms may end in orthodox horizontal serifs (or the faint fish-tail referred to in other letters). If the fish tail serif is used in the I, it should be consistently used throughout that particular alphabet. On the other hand, both arms may be raised and bend over at the ends reminding one of the pantomime caricature of a ghost but without the drapery. Ill drawn, the result may be comic, but gracefully delineated the extended arms of a Y may be as graceful as one could wish for.

Z is a medium to wide letter. It does not occur in the Trajan inscription, but is an importation from Greek 'loan' words.

If the Z were made with a chisel-edged pen or broad, flat brush, the 'natural' position of the thick and thin strokes would be for the horizontals to be thick and the diagonal thin as in (1). Many people find this horizontal emphasis with a comparative weak middle unsatisfactory, and therefore make the horizontals thin and the diagonal thick. It is thus the only letter of the alphabet in which a thick stroke runs from bottom left up to top right.

The lower arm (as in E and L) may on occasion be extended into a flourish.

The structure of the ? is governed by the pen and the position of the thicks and thins is governed by how they would fall if the letter were written with an edged pen. Details have of course, been modified to suit the method of manufacture.

(1)

(2)

(3)

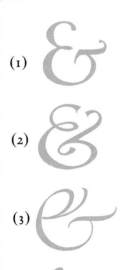

(1)

(2)

(3)

(4)

& This character is known as an ampersand. It is an abbreviated form of and—a short and. It is an ancient monogram of the letters e and t—the Latin word *et* meaning and. The name ampersand is possibly a corruption of the mixed English and Latin phrase 'and *per se*, and'. F. W. Goudy traces this monogram back to the seventh century and identifies over a hundred varieties, in many of which it is almost impossible to detect the e and t, but in some it is easy to trace the calligrapher's cursive E to the final flourish of which he has added the cross-stroke to form the t (3). Once this is accepted as a single character, the numerous variants are an understandable development. The form given above is the one which harmonises most readily with Roman capitals as being rather formal.

It is a medium to wide character with a diagonal emphasis. The counters should be carefully observed. As it was originally a pen form the student will understand and draw it better if he practises it a few times with a chisel-edged pen, allowing the thicks and thins to fall as the pen dictates, before drawing the above more formal version.

Lower-case or minuscule letters were evolved by scribes between the second and ninth centuries. The direct ancestor of the type you are reading is the minuscule developed by Alcuin of York in the employ of Charlemagne at the monastery of Tours about A.D. 800. It is known as the Carolingean or Caroline minuscule after Charlemagne. In the fifteenth century, this minuscule was revived in Italy, so that when printing was introduced from Germany there was a good tradition of penmanship to provide excellent models on which to base printing types. At first, all types were virtually copies of a scribe's pen forms, but it was not long before typographic punch cutters made the modifications to the details of letters they felt their tools and technique justified. One of these modifications is clearly seen in the final to (3). The pen naturally makes a point as (1) or a flat end as (2) whereas the graver and file of the punch cutter make a rounded finial (3) with equal facility and propriety.

Italic forms were developed from lower-case; the chief formative influences being speed and the need for a narrower letter to save space. In fifteenth-century Italy this cursive handwriting reached virtual perfection and we are now experiencing a devout revival of Chancery Italic. The letter given here is not a cursive pen form

(1)

(2)

(3)

cd

abcd

ef

efgh

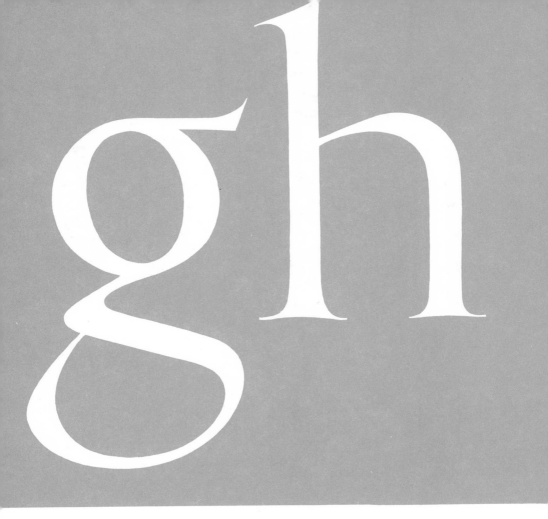

but a more formal version for use in sizes of two or three inches.

Of these lower-case letters the g is probably the most difficult. The bowl is often circular but is variable in size. The link might lay along the base line as in Caslon type (1), or swing diagonally down before making a sharpish turn into the loop. Don't make the loop and the bowl the same size and shape. To paraphrase Eric Gill—because a pair of spectacles is rather like a g, don't make a g like a pair of spectacles (2).

The cross stroke of e is, in formal lettering, usually horizontal, but there is an ancient tradition of sloping bars to the e. At the ends of lines the cross stroke may be extended into a flourish, particularly in the italic.

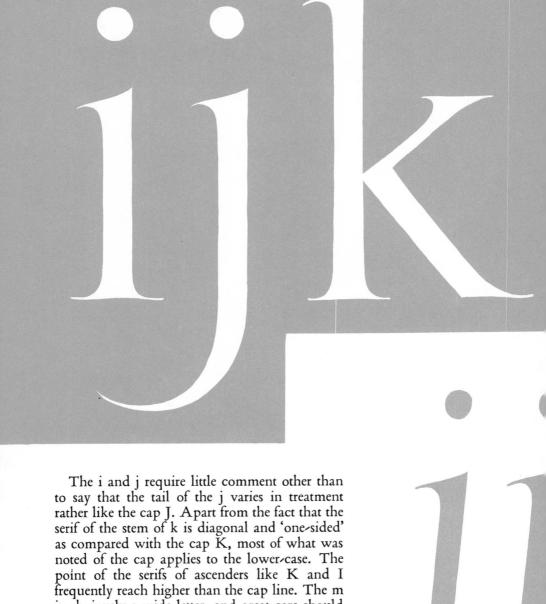

The i and j require little comment other than to say that the tail of the j varies in treatment rather like the cap J. Apart from the fact that the serif of the stem of k is diagonal and 'one-sided' as compared with the cap K, most of what was noted of the cap applies to the lower-case. The point of the serifs of ascenders like K and I frequently reach higher than the cap line. The m is obviously a wide letter, and great care should be taken in the drawing of the counters to keep them open. Note the point where the first arch joins the stem and the point where the second arch joins the first.

lm

klmn

no
opqr

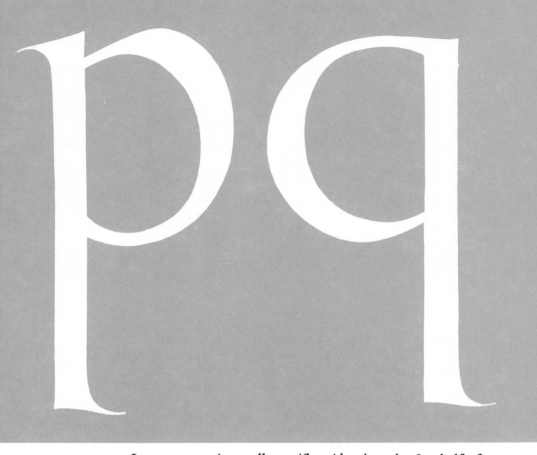

Lower-case n is usually a trifle wider than the first half of m. What was said of cap O applies to the lower-case. The adage 'mind your p's and q's' has a certain appropriateness for the learner letterer. A q is not the reverse of p. Note that in p the bowl springs away from the top of the stem at a point, but there is a slight thickening when it rejoins the stem just above the base line. The bowl of the q attaches itself to the stem at the top with a modest thickening, but just above the base line the attachment is a mere point.

In the course of time the bowl and tail of the cap R have shrunk to the gay little flag of a stroke that flies at the top of

rst

the stem in the lower-case r. This stroke may join the stem just below the top but, particularly in italic, it may emerge as a tangent about half-way down the stem. After the hair-line leaves the stem the stroke pulls away to the right to form a kind of diminutive tail. It should normally be short.

The comments on cap S apply to the lower-case. The cross stroke of the t lies just under, not just over, the mean line; that is, the *top edge* of the cross-stroke lies along the mean line. If t occurs at the end of a word or line the cross-stroke may extend into a flourish. It is affectation to allow the stem to stick up too far above the mean line—a modest triangle is adequate.

The curve at the foot may be generous or quite small.

The u varies considerably in width and should be the same as n. The serifs are at an angle which they are not in the v.

The italic forms are all a little freer. The more light-hearted the occasion the freer the lettering can, with propriety, be. Even the hair-line of the serif may flourish.

Letters s and t may be joined together by a ligature, which is the little connecting stroke.

uv
stuv

WX

wxyz

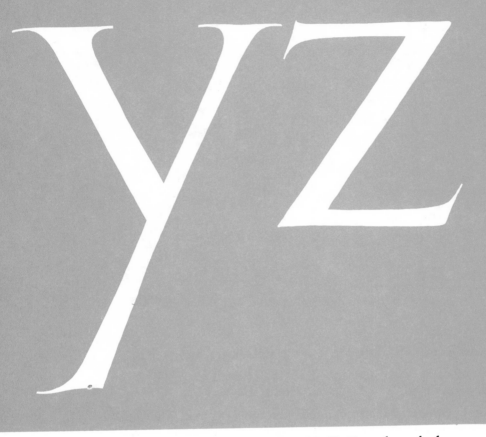

Most of the notes on cap W, X, Y, Z apply to the lower-case, with the exception of y. In the lower-case the splayed arms finish with horizontal serifs on the mean line and any freedom or jollity occurs in the tail. But the tail should normally be restrained in the formal lower-case; frivolity of flourish being reserved for the right occasion and more aptly in italic.

a b c d e f g h i j k l

m n o p q r s t u

v w x y z æ œ fi

The Romans used the letters of the alphabet for figures thus:

M=1000, D=500, C=100, L=50, X=10, IX=9, VIII=8, VII=7, VI=6, V=5, IV=4, III=3, II=2, I=1.

Combinations of these produced the other figures. The difficulty these must have created for arithmetical calculations is easy to imagine, and it is not surprising that the Romans were not as advanced in Mathematics as were the Arabs, who devised the system of figures and figuring in tens some centuries later.

The figures we use, then, are of Arabic origin, but they have been fashioned for so many centuries by letterers brought up on classical Roman lettering that they might be said to be naturalised.

They may all be the same height, as in the following large figures, and known to typographers as 'modern' or ranging figures. On the other hand, as on the opposite page, they may be of unequal height and known as 'old style' figures. Figure 4 is seen sometimes resting on the base line and not as a descender.

1 2 3 4 5
6 7 8 9 0

1 2

$$\frac{34}{56}$$

$$\frac{78}{90}$$

OTHER FORMS OF LETTER

On the pages that display the drawn Roman alphabet we submit for comparison Gill Sans, and as the initial letter of the text, 24 pt. Poliphilus Titling, a faithful copy of an Italian late fifteenth-century type. But these are not the only satisfactory forms of letter—on the contrary—they are to be regarded as a beginning and not an end.

As soon as we think about other forms of letter we are plunged into the ticklish subject of the classification of letter forms which we can only touch upon here. As we said at the beginning, all the twenty-six letters used in the English language are Roman or derived from Roman, but some of the derivatives have such strongly marked characteristics and are in such common use that names are necessary to distinguish the main groups of letter form. On the opposite page will be seen the four largest groups of letter forms, with the differentiating features described.

It is evident that 'old face' letters come nearest to classical Roman forms. This is not surprising because old face letters are but slightly altered from the shapes given them by humanist scribes in fifteenth-century Italy. They have the richness, mellowness and serenity of the classical tradition.

Fat

Face

Latin

Script

Copper plate engraving had an influence in bringing about the horizontal hair lines and unbracketed serifs of the 'modern face' which became fashionable in the late eighteenth century. An extreme thickening of the stems, leaving the hair-lines as hair-lines, produced the 'Fat Faces' which enjoyed a vogue in the early nineteenth century and have again found favour with many designers. Fat faces were not confined to paper advertisements but appeared in less perishable material solemnly on gravestones.

Sans serif letters, as we have pointed out, are to be found on the earliest of Latin inscriptions, but the absence of subsequent development and lack of refinement suggests that the serifs were omitted less by conscious choice than by practical necessity or knowing no better way. Certainly no fine early sans seem to be known. In the early nineteenth century and again in this, sans serif letters have been deliberately designed—consciously different from the normal. Today sans letters are so common as to be reasonably called 'normal'—at least outside the pages of books.

Slab serif letters, also familiar today, are an early nineteenth-century innovation—at least it was then that slab serif lettering appeared on Regency architecture, on playbills, title pages, and other printed matter.

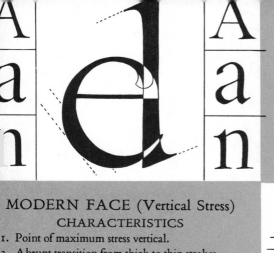

OLD FACE (Diagonal Stress)
CHARACTERISTICS

1. Point of maximum stress at an angle.
2. Gradual transition from thick to thin strokes.
3. Little contrast between thick and thin strokes (there are exceptions).
4. Serifs bracketed.
5. Serifs of lower-case letters like d, b, n, m, etc., at an angle (see diagram).

Good Old Face types are Bembo, Caslon Old Face, Garamond, Plantin.

MODERN FACE (Vertical Stress)
CHARACTERISTICS

1. Point of maximum stress vertical.
2. Abrupt transition from thick to thin strokes.
3. Strong contrast between thick and thin strokes (hairlines).
4. Serifs usually (but not always) unbracketed.
5. Serifs of lower-case letters like d, b, n, m, etc., horizontal.

Good Modern Face types are Bodoni, Walbaum, Bell, Scotch Roman.

SANSERIF
(Block, Gothic, Grotesque)
CHARACTERISTICS

1. As the name implies—absence of serifs.
2. Usually no difference, or little difference, in thickness between the strokes which are normally thick and those normally thin.

Good Sans types are Gill Sans, Cable, Erbar, Johnston's Underground Sans.

SLAB SERIF (Egyptian)
CHARACTERISTICS

1. The serifs about the same thickness as the stems.
2. Usually the serifs are unbracketed, though there are notable exceptions.
3. Sometimes, as in the Playbill, the serifs are thicker than the stems.
4. Generally a 'monotone', that is, having all the strokes the same thickness, but again there are exceptions.

Some Slab-Serif types are Beton, Rockwell, Scarab, Luxor.

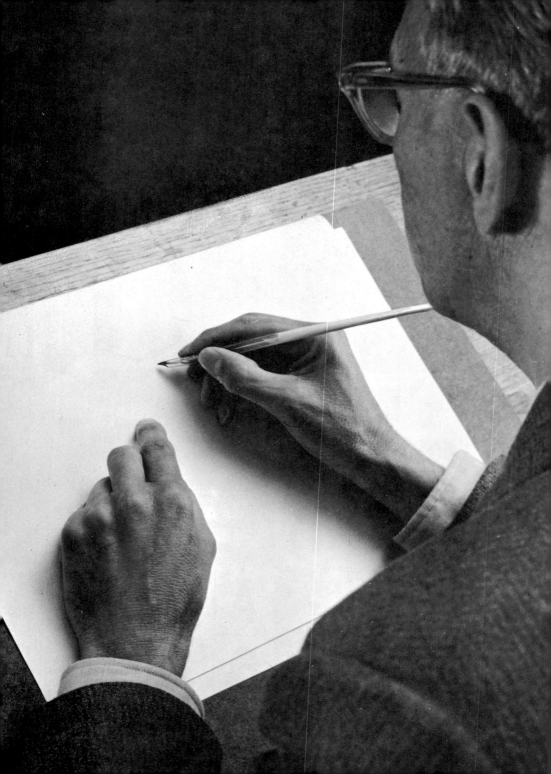

THE
CRAFT
OF THE
PEN

Spinoza

Sparkling calligraphy by Gerritt Noordzij engraved on wood by him.

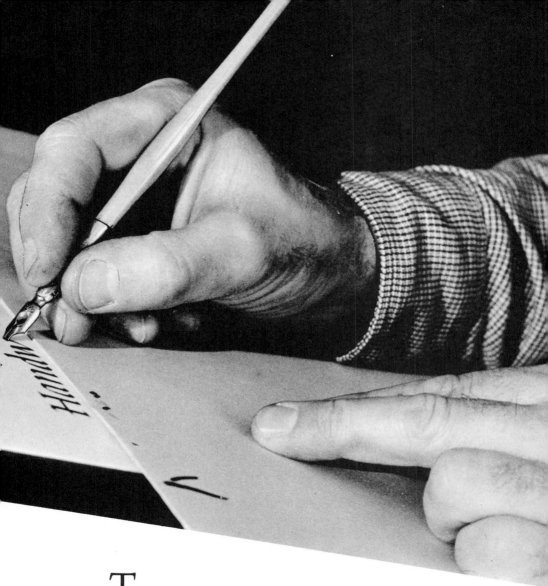

THIS book is not yet another of the many which aim at improving everyday handwriting by a study of fifteenth-century Italian cursive hands in general and Chancery Italic in particular. In this section we consider the pen as an appropriate instrument for the production of small posters, book jackets, showcards, and the numerous ephemeral notices needed for schools, churches, clubs and exhibitions and where letters two or three inches high are required. Where only one copy of anything is required it is

absurd to employ the mass-production process of printing and even when two, three or six copies are required writing is often more economical of both time and money, and, by the hand of a competent craftsman, can be freer and more creative.

A suitable text or epigraph to this section might be 'Type follows the Pen'. By that we do not mean that type could or should try to reproduce pen forms—far from it. The production of type is an art-craft (or perhaps an art-craft-industry as all three play a part) in its own right; but there is a sense in which it is not self-fertilising in the way that penmanship is. The design of type seems to require the inspiration of the pen, indeed, it is difficult to think of a good type designer who is not a good pen-man even if he does not regard himself as a professional calligrapher.

The forms of the great medieval hands can still be an inspiration to the mid-twentieth-century letterer, indeed, how can we fully understand the letters we use unless we know their origins? But we must adapt them to contemporary needs, circumstances and scales—a spring-board not a landing-stage. Most of the early scribe's work has been taken over by the printer in the production of the text of books. Today it is not long continuous texts in small writing which is required of the calligrapher, but small quantities of larger letters for book jackets, showcards, television and cinema titles and 'credits'.

This affects the design of the individual letters and their relation-ships one with another; the choice and contrast of sizes and the general layout—a cinema screen or a showcard is not a blown-up page of a book and a book-hand is not necessarily appropriate even though the new forms may be the descendants of book-hands. But the writing of larger letters also effects the physical manipulation of the pen. Small writing is largely finger work, the fingers providing the up and down movements while the wrist remains virtually stationary apart from the movement at intervals across the page. To form letters two or three inches high the whole arm must move down the page, the fingers remaining in an almost unaltered hold of the pen. If small writing comes from the fingers, large writing, one might say, comes from the shoulder.

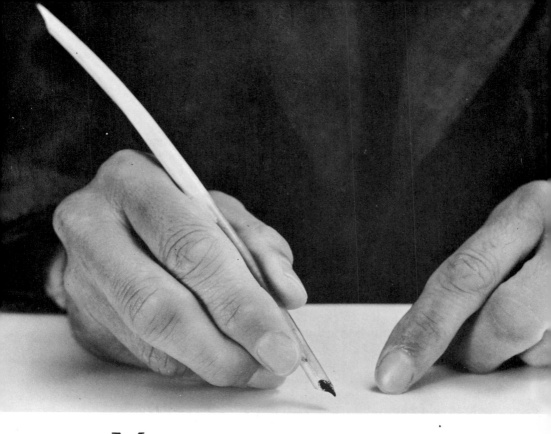

MASTERY of the craft of the pen demands technical knowledge of the behaviour of pens, inks, and papers, and skill in their manipulation, together with taste and aesthetic judgement in the choice of the right forms of letter. The essential forms of our alphabet have been settled for us by centuries of usage and by their very nature are slow to change. It is not required of the penman to invent a new alphabet but to make the existing alphabet as well as he can by exercising a disciplined taste in the formation of legible and lively letters. On the one hand he should not be afraid of a little fun of flourish if the occasion is appropriate, but on the other hand he should guard against vulgar and ostentatious eccentricities. Sober legibility is preferable to inebriate showmanship. It is better for the learner to study and master sound traditional shapes before trying to invent new forms.

The shapes and proportions of the letters of our alphabet are derived from Roman capitals of the first and second centuries A.D. These were copied with an edged pen which soon made its

influence felt and modified the forms of the letters. Gradually capitals (majuscules) evolved into lower-case (minuscules), and with the need for speed and compression minuscules were in turn modified to produce italic. There are thus three distinct alphabets we use today.

Capitals: ABCDEFGHIJKLMNOPQRSTUVWXYZ.
Lower-case: abcdefghijklmnopqrstuvwxyz.
Italic: *abcdefghijklmnopqrstuvwxyz.*

What we know as Italic capitals are really sloped roman caps.

The position of the thick and thin strokes in our letters is determined not so much by deliberate intention, as by the way the pen is held and moved. The order in which strokes are made also plays a part in creating the shapes of letters—but the number and order of strokes depends on the size of letter. Italic minuscules about an eighth of an inch high which can be made with one stroke, might require three strokes if the letter was three inches high.

The enclosed 'background' shapes of letters are known as counters (see page 81), and are as important in shape as the strokes the pen makes. The background enclosed is as much part of the letter as the strokes themselves, and care should be taken that the counters are kept open, clean and unfussy. It is usual to think of the proportions of letters in relation to a square: thus as an O is circular it will occupy a square. The E, F, L, P, and S occupy about half a square. But there is no need to measure this with ruler and compass—good proportions of letters are more a matter of feeling than geometry. No amount of mathematics will com-pensate for a lack of sensibility and judgement. The widths of letters may need to be modified according to the circumstances of their use. For example it may be necessary to reduce the width of both L and A if they follow one another as in the word LADY. Also when A follows R the tail of the R might be reduced. On the other hand at the end of a line the tail of the R might appro-priately be prolonged into a flourish.

It would be wisest for the beginner to follow the normal pro-portions—training the eye to recognise the permissible limits of

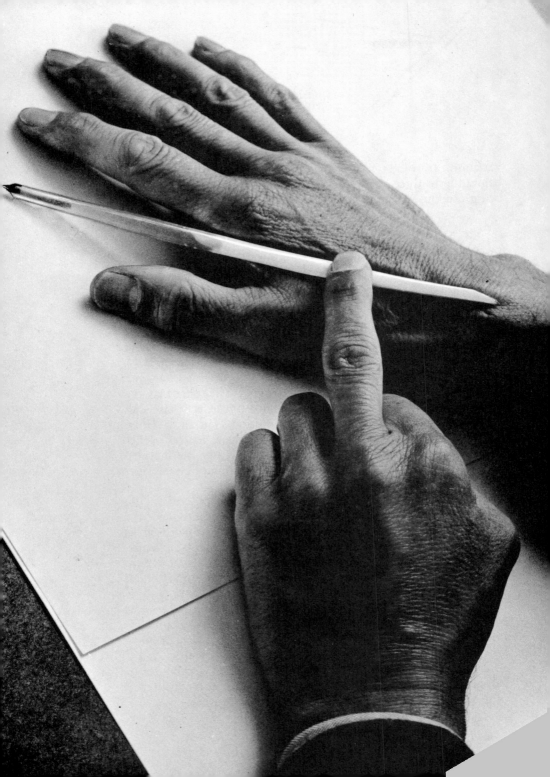

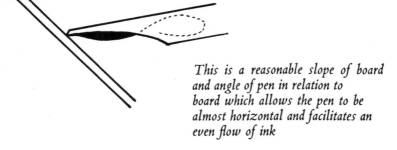

*This is a reasonable slope of board
and angle of pen in relation to
board which allows the pen to be
almost horizontal and facilitates an
even flow of ink*

variation. It is best to think of the capitals or majuscules as belonging to three groups according to their width (the I and J being obvious exceptions).

1. Wide letters occupy a square—more or less—O, C, D, G, Q, W, M.

2. Medium letters occupying about three quarters of a square—more or less—A, H, K, N, T, U, V, X, Y, Z.

3. Narrow letters occupying about half a square—or a little more—E, B, F, L, P, R, S.

There will be times when the A or K might fill a square and when the T or Y take only about half a square, but the above classification is a sound one to have at the back of ones mind.

The effectiveness of writing depends not only on the shapes and proportions of the letters but on their spacing. The space between words should be about the width of a medium letter for capitals and the width of an n for lower-case (minuscules). If all the letters are wide and the last and first letters have adjacent vertical strokes a little more space might be better—but if, say, one word ended with L and the next began with A, the width of a narrow letter (half a square) would be ample.

The interlinear channel (see page 81) is important, and should normally be not less than two x heights to accommodate the ascenders and descenders. It is helpful to think of writing as horizontal bands of texture or tone separated by bands of white. One should endeavour to foster this horizontalness in order to assist the eye along the lines and to discourage anything which tends to divert the eye across the lines. An appreciable interlinear channel minimises the chance of reading the same line twice as well as permitting graceful ascenders. When space is short descenders may be reduced a little without loss of legibility or grace whereas clipped ascenders look ugly and are less legible.

One of the most important, if difficult to define, qualities in calligraphy is rhythm; and that evenness of tone, and consistency of accent in the alternation of thick and thin strokes.

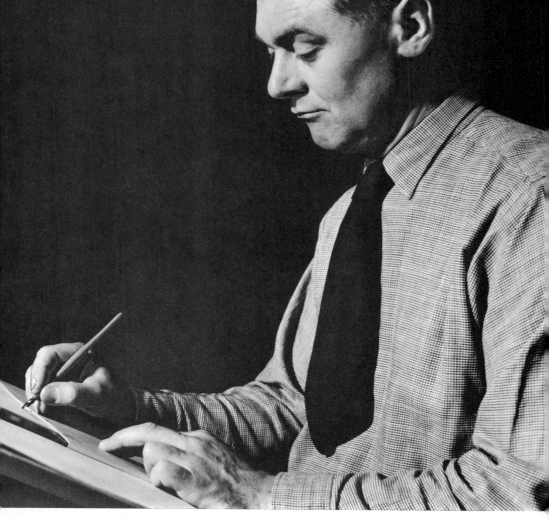

POSTURE

It is characteristic of all good craftsmen to stress the importance of correct posture, that is, the correct way to sit or stand or hold ones arm, body or feet to achieve ease of manipulation, minimum of fatigue and the effects that can only be obtained through right posture. This is particularly true of penmanship which depends so much on the proper height of desk and chair so that in a seated position the feet do not dangle and the body is comfortably erect without crouching (if the drawing board or the desk is too low) or straining up (if it is too high). The penman should be so seated that his arms can move freely and his back held in an easy relaxed upright position as the above photograph.

*Angle of
pen's edge to
writing line*

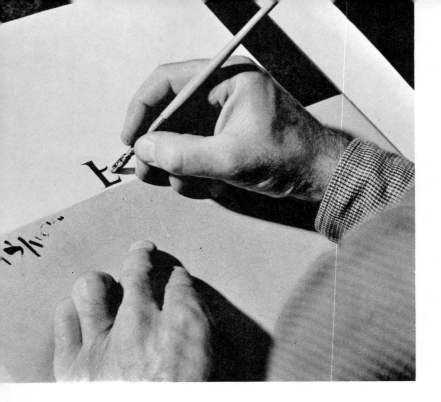

PEN HOLD

The way the pen is held, its relation to the fingers, its angle in relation to the arm and the body are most important though there is bound to be variation owing to the differences of anatomical

It is best to pin paper over lower part of board to protect the writing paper and leave it exposed at the level the writer finds most comfortable. Always write at about the same level.

Tape or strip of paper.

Writing line.

Paper on which to rest hands and to keep the writing paper clean.

structure between individuals. First, as with posture, the writer must be comfortable; which means, within reason, holding the pen in the manner he is accustomed to. Edward Johnston said 'we

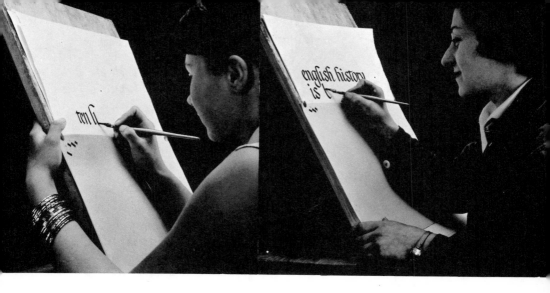

should hold the pen in the way which, by long use, we have been accustomed; provided that, for writing an upright round hand, the pen be so manipulated as to make fine horizontal thin strokes and clean vertical thick strokes.' In practice this means holding the pen as the photographs on pages 71, 73, 77, 78—the pen resting between the thumb and the first and the second fingers so that the shaft of the pen lies along the hand like an extra finger pointing over the right shoulder. The photograph of Mr Alfred Fairbank on page 75 shows the pen lying along the hand before being gripped. The word gripped is perhaps too strong a word—held is better. However the pen is held, there should be no sense of tension. Little pressure is required to write—the thick strokes are the result of the direction the pen is moved in—not of pressure. Let the pen glide easily too and fro across the paper—skating not scouring.

Writing Level. After a little practice and trial and error it will be found there is one particular level when arms, fingers, and back are most relaxed and when in consequence the writing comes most easily. At this level, pin a sheet of paper across the lower part of the board and so protect the sheet being written on from the hazards of a dirty cuff or a sweaty hand. As each line is written the writing paper is drawn up to expose a new line. A tape across the upper part of the drawing board (or writing table) will keep the written work from curling as more of the sheet is exposed (page 78).

Reeds and quills may be cut at an angle enabling the thickest stroke to be vertical without altering the angle of the pen in the hand (A).

The pens used in the preparation of this section are of four main kinds, namely (1) The reed or cane pen with which the examples on pages 120–123, were written. (2) The steel pen. (3) The felt-tip pen which produced the largest letters on pages 90 to 119. (4) The fountain pen which was employed for the arrows and figures indicating the order of direction of pen stroke and the italic writing on pages 62 and 63. The choice of instrument may be determined by the size of lettering required, the nature of the material to be written on and the writers own preference or mood. Some of the examples here made with a reed might just as well have been done with a steel pen and vice versa.

The Reed Pen. As the name implies is cut from a reed (or piece of cane) with the pith removed from the hollow core as shown in the diagram on page 82. When the split is made with a really sharp knife care must be taken to prevent the split extending too far. A reservoir to retain ink in the pen is placed as in the diagram on page 83 so that one end is about an eighth of an inch from the tip and the other end in the hollow stem of the reed. A suitable metal for the reservoir is the thick metal foil with which some tins of tobacco and instant coffee are sealed. This may easily be cut with ordinary scissors into strips about one sixteenth of an inch wide and about one and a half or two inches long. Dipping the pen for a few seconds in clean water before use helps the first charge of ink to flow easily. The advantage of a reed (or quill) is its flexibility, sympathy, and response to minute variations of touch. A cleanly cut reed or quill is a joy to work with, but skill and experience are required to cut one properly.

The Steel Pen. The great advantage of the steel pen is its consistency. Reservoir holders are best for most sizes (pages 82–83), but some of the larger sizes of nibs are supplied with an attached reservoir. They may be obtained 'straight' or angled either to left or right.

All the above-mentioned pens are best charged with ink by means of a brush—a cheap camel hair brush is adequate. Try to

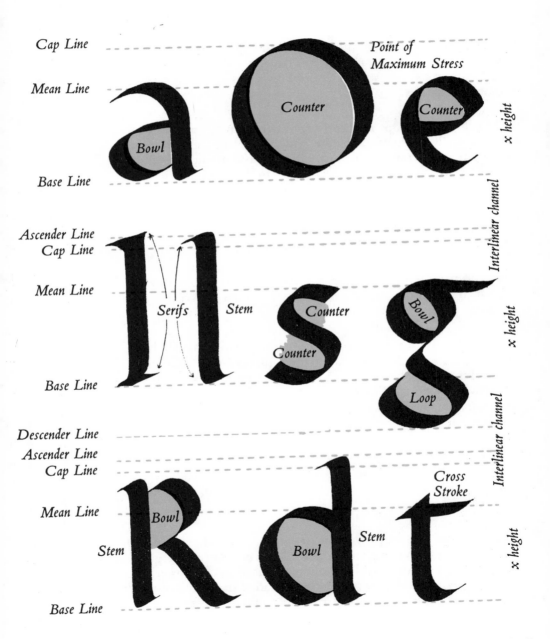

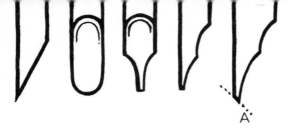

*Cutting a reed or quill pen.
Use a very sharp knife.
Note the angle at A which
makes clean fine strokes
possible.*

keep the pen moderately full of ink all the time. Too much ink
will tend to write heavily making fine hair-lines almost impossible.
Too little ink can result in crumbling edges and perhaps in-
completed strokes.

The Felt-tip Pen. This is a fairly recent invention, and is useful
commercially on account of the wide variety of surfaces upon
which it will write—cardboard, wood, glass, metal, as well as
paper. The large letters on pages 90–119 were written with a
Flomaster, a felt tip fitted into a reservoir, the size and shape of a
large fountain pen. A spring valve controls the flow of ink to the
felt nib. By pressing the nib into the holder for a second or two a
fresh supply of the highly volatile ink is allowed to seep into the
felt. This must be done every so often in order to keep the tip
supplied with ink, the pen will then continue writing like a
fountain pen until the reservoir is empty. A screw cap covers the
tip when not in use, and it can be carried in the pocket like any
fountain pen.

Boxall Pen. This is a non-rusting metal pen suitable for large
lettering as it is made in sizes up to three quarters of an inch wide.
One of the blades has fine slits in it which should be kept upper-
most when writing. The plain blade should not project beyond
the slotted blade otherwise it will not write. Whatever the pen—
wash it and clean it well after use.

The Fountain Pen. There are now a number of excellent fountain
pens available with chisel-edged nibs suitable for calligraphy
though the maximum width of the nib is limited to about a
sixteenth of an inch.

Inks. The best inks to use with the reed, quill and steel pens are the
non-waterproof drawing or Indian inks. There are many good
makes that are purchasable at all suppliers of artists materials,
and it is a matter of personal preference rather than difference of
quality to choose between the reputable makes. These may be

*Reservoir
Holder*

Top view

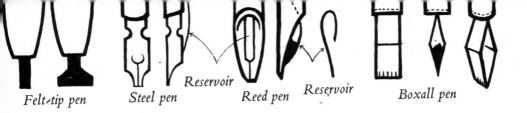

Felt-tip pen Steel pen *Reservoir* Reed pen *Reservoir* Boxall pen

Side view

diluted with water if necessary. Waterproof Indian ink is not recommended as it is too gummy and soon chokes the pen.

Paper. The finest penmanship of all time has been done on vellum, and any surface which resembles vellum in its smooth silky receptiveness is to be desired. Hard rough surfaces are difficult to write upon. For the first few exercises an inexpensive M.G. Printing paper is good enough, indeed, for practice with two pencils joined together, almost any paper will do. As soon as the shapes of the letters are learned and the order of pen strokes has become familiar better papers are recommended, such as Mellotex Cartridge, Turkey Mill, Nippon-vellum, Basingwerk Parch- ment or any good writing paper. Most of the specimens for this book were written on a white paper called Plus Fabric bought from a local printer. This has a cool white smooth surface which takes kindly to the pen and ink, but will not endure erasures. As this paper is slightly transparent a faulty sheet of writing can be placed under a clean sheet allowing the writing to be done afresh with the benefit of the first writing showing faintly through and so acting as a guide. Both spacing and the form of letters can be improved in this way.

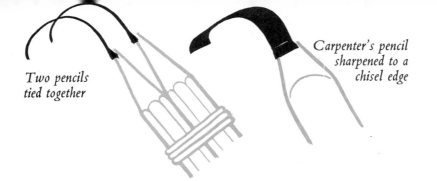

Two pencils tied together

Carpenter's pencil sharpened to a chisel edge

Two pencils (the hexagonal kind is best) held together with string or elastic bands make a good substitute for a pen for a beginner to practice with. The two points of the pencils are equivalent to the two ends of the edge of the pen. The resulting lines made when the pencils are held and used like a pen, show clearly the relationship between inside and outside contours of the strokes. The resulting letter is also quite effective and encouraging to the beginner before he faces the hazards of the pen. The carpenter's pencil is also good to practise with but it is not so easy to produce crisp contours.

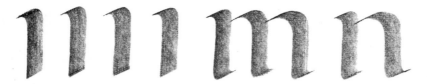

The letter m typifies the rhythm of the lower-case. It is good practice to write the alphabet with an m between each letter thus:

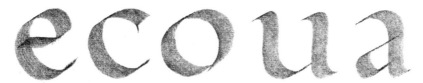

ambmcmdmem and so on. This method was recommended by the old writing masters.

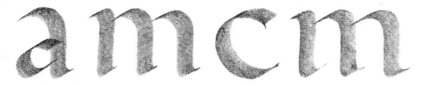

acem

imor

suvx

twvz&

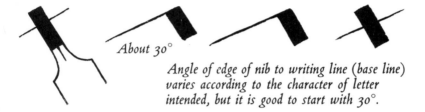

About 30°

Angle of edge of nib to writing line (base line) varies according to the character of letter intended, but it is good to start with 30°.

After some practice with pencils try similar exercises with a pen. First attempt diagonal thick strokes as shown here.

Then make a series of thin diagonals at right angles to the thick strokes. These are more difficult to keep consistent. They are made by moving the pen from bottom left to top right.

Next practise a series of vertical strokes as seen below. Endeavour to keep the strokes evenly spaced and regular in height. Be as relaxed as possible and cultivate rhythm.

Horizontal strokes should be practised next; but remember to keep the pen angle the same whether the stroke is made diagonally, vertically or horizontally. Again aim at keeping the strokes a uniform length and a uniform distance apart. Repeat all exercises as often as you can without boredom. Move on to another exercise just before boredom sets in.

TTTTTT

Having mastered the basic strokes and gained a sense of rhythm, combine the horizontals and verticals into letters such as T, E, F, L again aiming at evenness of spacing.

EEEEEEE

Then combine diagonals with horizontals as in the letter A; diagonals with verticals as in K, M, N, Y. When all the letters have been practised individually combine them into words and lines.

AAAAA

Now try making curves, moving the pen in the arrow's direction (*a*)

Then practise making curves in the opposite direction, thus (*b*).

Combine the two strokes to make an O (and Q, C, G).

After making a number of O's try the related C and G.

The C is the whole of stroke (*a*) and about a third of stroke (*b*).

The G is C with a short vertical rising from the lower arm.

GGGGG

The Q is of course an O with a tail on. The tail is modest.

QQQQQ

D combines a vertical with a curve and a short horizontal.

DDDDD

R is a vertical, plus a curve and a strong diagonal stroke.

RRRRR

Practise every letter many times to acquire form and rhythm.

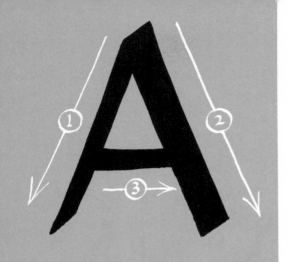

The letter A is a medium to wide letter. Guard against narrowness. Keep the cross stroke slightly below the middle.

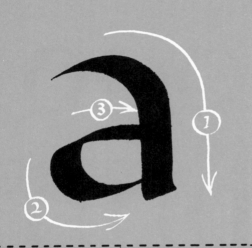

In the formal version make the arch round and the stem vertical. Do not make the bowl too large.

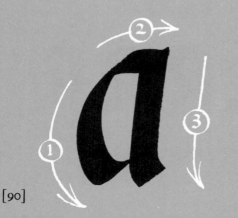

The small size can be made in one stroke but the large size might require two or perhaps three strokes.

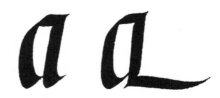

Is best a medium to narrow letter. Resist the temptation to make a bulging lower bowl.

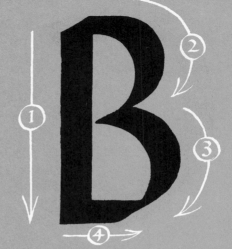

Preserve a clean open counter.

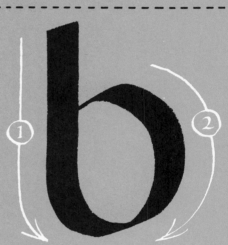

The small size can be made in one stroke, the large size in two strokes.

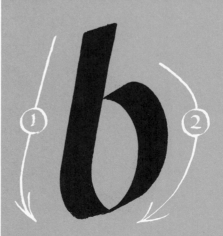

C is a wide letter. The upper arm is best kept fairly flat.

The formal version is well rounded.

May be made without lifting the pen by making a short stroke towards the right returning over the same ground before swinging down and round.

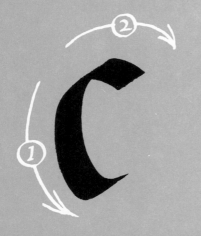

D is a wide letter, and well rounded.

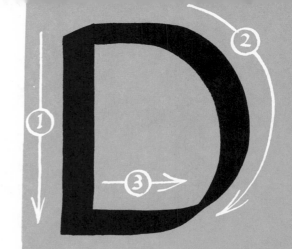

The upper part of the bowl tends to flatness.

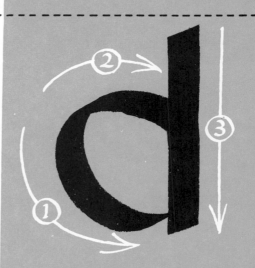

The small size may be made in one stroke.

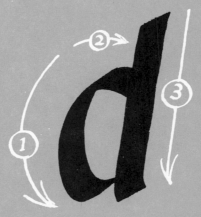

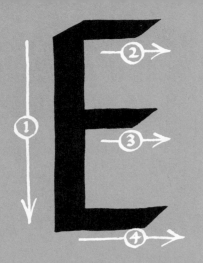

E is a narrow letter about half as wide as it is high.

The cross stroke may be horizontal or slightly sloped. It may also be extended.

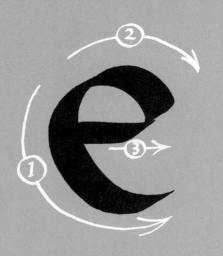

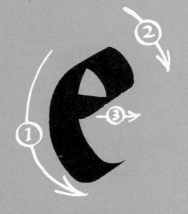

Even the small size requires two strokes to write it properly.

The same width as E—narrow. The serif on the upper arm of the free version is made by tilting the pen on its edge as it is lifted off the paper.

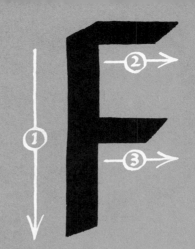

Note a tendency to flatness at the top. Stem does not descend below the line.

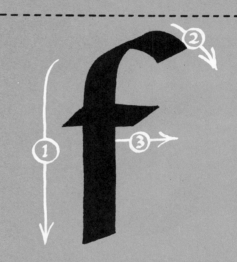

Has a generous descender. The cross stroke lends itself to extension.

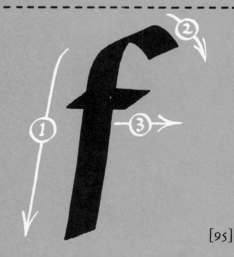

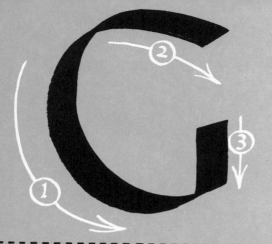

G is a well wide rounded letter. The upper arm tends to flatness. The short vertical stroke should not be carried too high, but on occasion it may be extended.

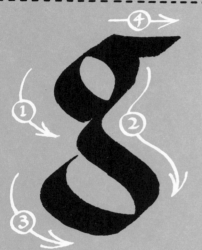

This letter may be thought of as a small o with a looped tail. Keep all counters open and make the loop slightly wider than the bowl.

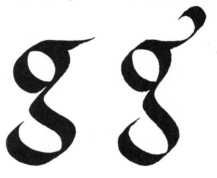

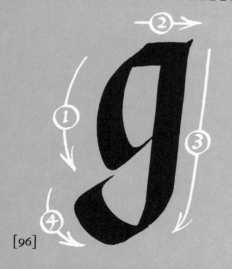

The italic *g* is virtually a c with an added vertical which swings beneath the bowl to form a loop.

A medium to wide symmetrical letter which must be precisely proportioned to avoid dullness.

Keep the arch firm and round. Almost an n with an extended first stroke.

As with all the italic letters—narrower than the roman. The ascender may be flourished.

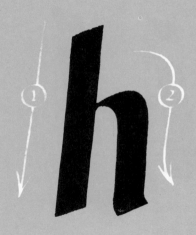

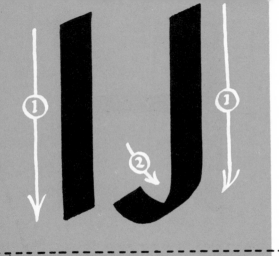

J was unknown to the Romans. J was, and is, made by adding a curved tail to an I.

These letters are so straight for-ward as to need little comment. Avoid a large tail.

These letters are so straight for-ward as to need little comment. Avoid a large tail.

Both simple letters. If the j is on the bottom line or otherwise has much space below it, the tail may be flourished.

K is a medium to wide letter. The two arms meet at a point on the contour of the stem; do not allow them to break into the stem which makes a clumsy join.

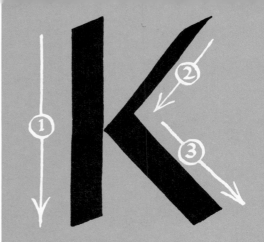

The above remarks apply also to the minuscule. Both arms may be prolonged into a flourish.

Again let the arms meet the stem at a point. The stem and lower arm may be extended into a flourish.

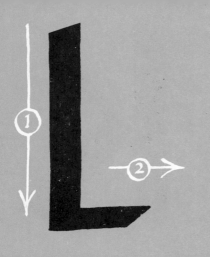

L is a narrow letter but on occasion both stem and arm may be lengthened and flourished.

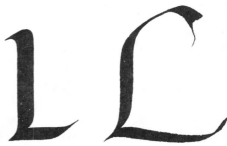

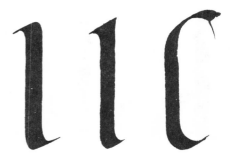

No comment is necessary.

The italic *l* may ascend (if there is ample room) into a flourish.

It is a wide letter and should never be unduly compressed. The 1st, 2nd and 4th strokes lend themselves to extension and flourishing.

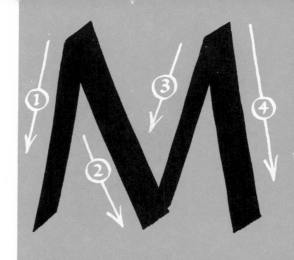

Keep the arches well rounded, particularly in the counters.

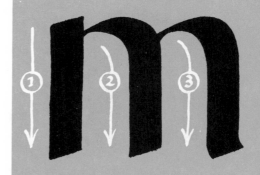

Narrower than the Roman, but the last stroke may sometimes end with a flourish. Sets the rhythm of a particular hand.

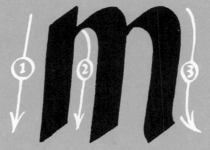

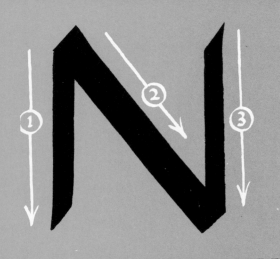

N is a medium to wide letter and any temptation to make it narrow should be resisted.

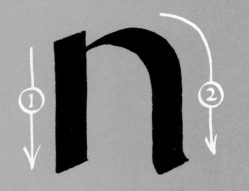

As with the m—keep the arch well rounded and fairly wide.

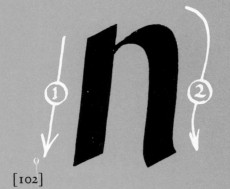

Virtually part of an *m* with similar rhythm and arch formation.

The angle of the pen dictates the angle of the axis of the O. Keep the counter as open as possible.

Virtually the same as the capital but written smaller.

The italic, being narrower makes the *o* eliptical rather than circular. Do not exaggerate the slope.

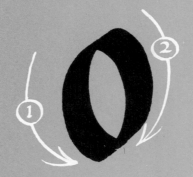

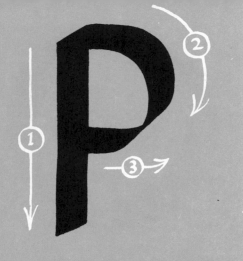

P is a narrow letter. Looks vulgar if the bowl is made too wide.

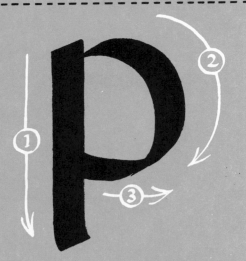

The bowl meets the stem at the top at a point but is thicker as it rejoins the stem lower down.

May be thought of as an *o* with a stem on the left.

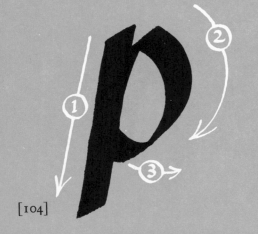

Q is like an O with a tail which should not normally break into the counter.

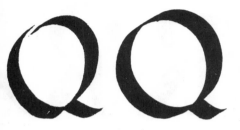

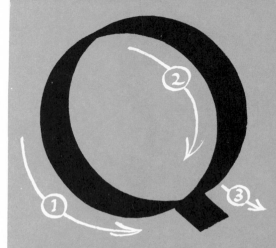

The bowl is thick when it joins the stem at the top but pointed as it rejoins the stem just above the line.

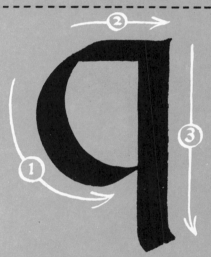

May be thought of as an *o* with a descending stem.

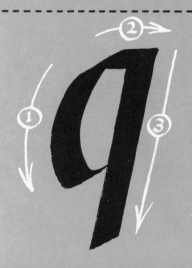

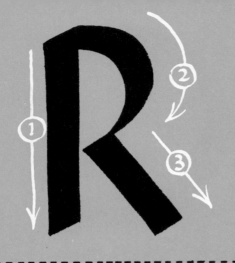

R is a medium to narrow letter. The bowl should not be made too wide but the tail may be extended.

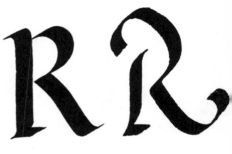

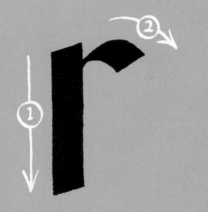

Definitely a two stroke letter.

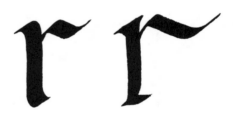

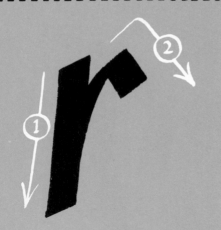

This may be made in one stroke. The little arm may be extended at the end of a line.

S is a narrow letter and not as difficult as many beginners suppose.

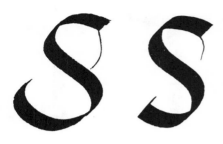

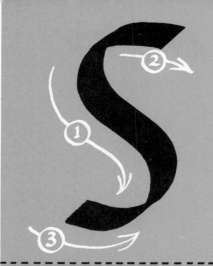

Virtually the same as the cap—a three stroke letter.

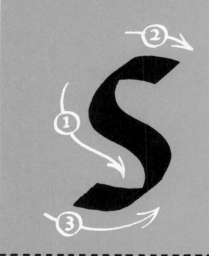

The small sizes may be made in one stroke.

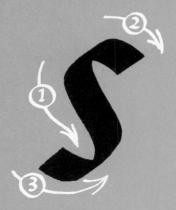

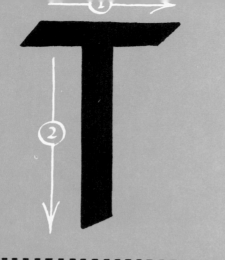

T is a medium width letter. The arms may be extended.

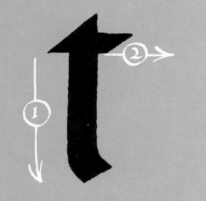

Do not turn the stem into an ascender.

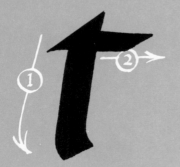

The cross stroke may be prolonged to join the next letter or flourished at the end of a line.

U is a medium to wide letter. Keep the curve rounded.

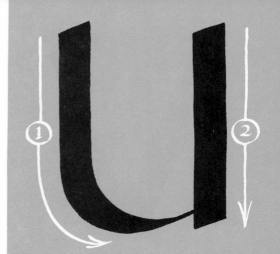

The same as the capital letter.

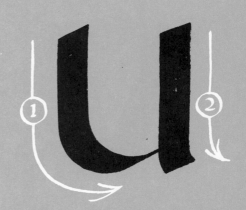

Almost, but not quite, an n upside down.

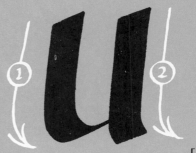

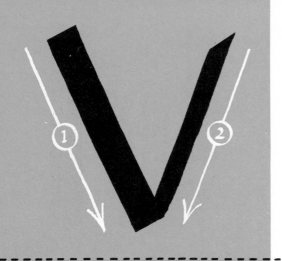

V is a medium-width letter, and should not be made narrow without good reason.

The same as the capital.

The small size may be made in one stroke.

Obviously a wide letter made up of two V's. Sometimes they cross over making four serifs at the top.

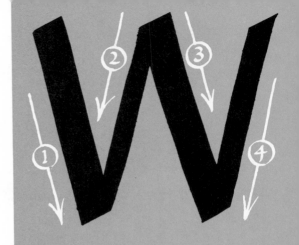

Also a four stroke letter.

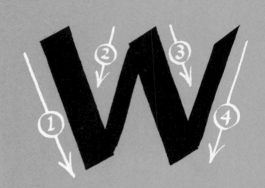

The small size may be made in one stroke.

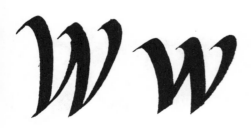

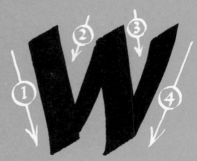

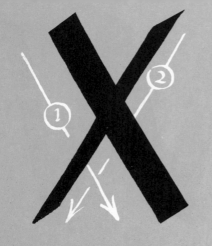

A medium-width letter. The arms may be flourished.

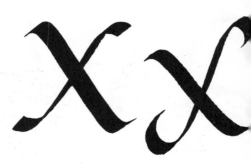

Same as above.

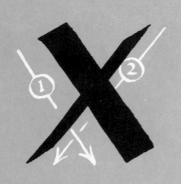

Is sometimes a *c* with half an *o* in front.

Be careful of the angle the first
stroke makes. A medium letter.

 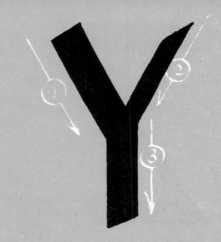

The tail lends itself to lengthening
and flourishing.

 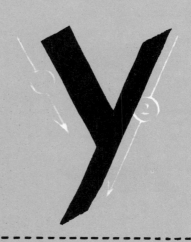

The italic lends itself even more to
flourishing.

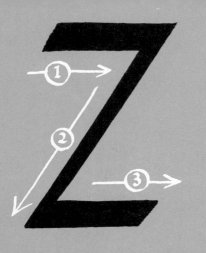

A medium to wide letter. The pen makes the diagonal thin but in type it is usually thick.

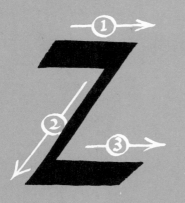

Virtually the capital written smaller.

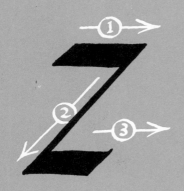

The lower arm may be extended into a flourish at the end of a line.

& is derived from et meaning and. The word ampersand is probably from 'et per se—and'.

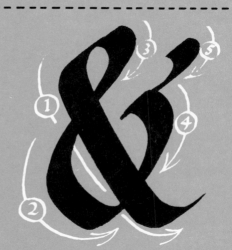

There are many versions, some of them pretty.

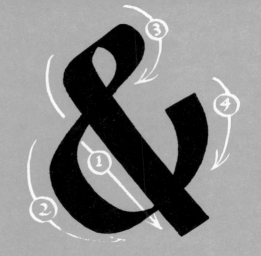

In some versions the E and the T are easily discernible.

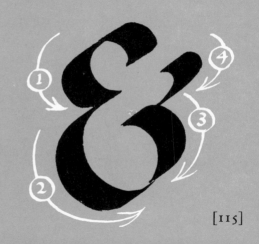

Sometimes difficult to distinguish from lower-case l. All the figures are of Arabic origin—not Roman.

Keep the neck gracefully rounded. Avoid an abrupt turn into the diagonal.

The flat top is perhaps too like a 5 —but is a useful version all the same.

The stem may rest on the line or it can be a descender.

 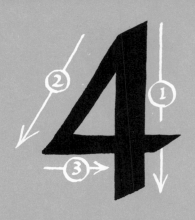

Is generally best with a fairly long 'neck' and a fairly small 'belly'.

 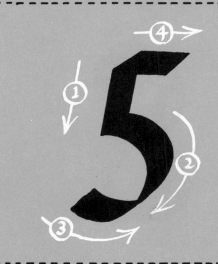

May range with the other letters or rise into an ascender.

 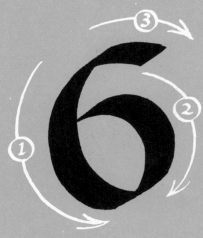

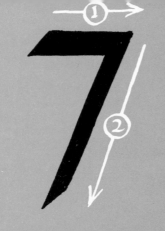

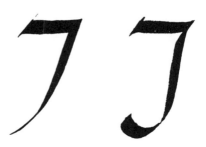

May range with other letters or extend into a descender.

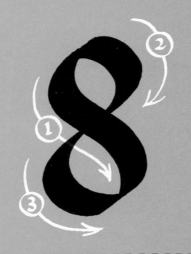

Not two O's on top of one another—it is almost an S with the arms curled round to join the stem.

Almost a 6 upside down. May be a descender.

Often narrower than an O.

Avoid a serpentine curve.

Aim at simplicity and avoid fussiness.

 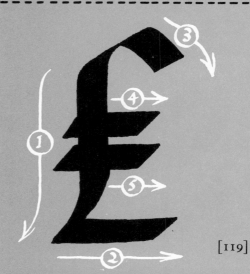

Freely written with a reed pen. About seven nib widths high.

ABCD
EFGH
IJKLM
NORQ
SRTU

Pen angle
about 30°

The three letters at the bottom are more frivolous
variants of the A, B, and C.

VWXY

Z & & ?

12345

67890

ABC

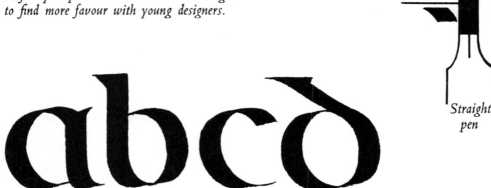

Straight
pen

abcd

EFGh

IJ k ln

mmp

QRSC

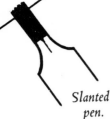

Slanted
pen.

ABCDE

FGHIJK

LMNOP

QRSTU

VWXYZ

Dear John,

I was terribly sorry to hear of your accident and I hope you will soon recover completely. It was kind of you to invite me to coffee & I shd. have liked to accept, but I find myself quite heavily involved with work just now. I have at least 30 hours' calligraphy to complete one more of the Beacon books & I can only see clearly enough in the mornings & my hand is steady then. This is but one job.

Part of a letter to me by Alfred Fairbank, CBE.

ABOUT HANDWRITING

Handwriting has been called 'Everyman's Craft' because it is the craft practised by all literate people. Some people find creative expression in pottery, needlework, metal-work, wood-work etc., which in almost every case will be different from their daily occupation. Most people earn their living in jobs that give little or no opportunity for self-expression—artistic or otherwise. They rarely produce anything of which they can say 'I did it,' or 'I made it' or feel that something of themselves is contained or reflected in the thing. But it *is* possible in handwriting. Everybody who writes with care and consideration for his readers can achieve a degree of satisfaction and a feeling of some artistic accomplishment.

Crafts like pottery, weaving and metal-work, which can bring similar satisfactions and a sense of creative fulfilment not possible in daily work, all require equipment and space beyond the means of most people. But few are so poor that they cannot afford a few pens,

Dear John, Legible handwriting is exactly as important as understandable speech. the main hindrance for civilised handwriting is the general belief that handwriting should be a

fate instead of a skill. The school fosters this belief. If we care for good handwriting we have to fight superstition at its origin: our system of education.

I like handwriting for its flexibility. It offers me a wide range of scripts, sizes and weights. To me handwriting is the cradle of design.

My typographic designs always start with trials in handwriting, but for my own texts I prefer the reproduction of the manuscript — avoiding the intervention of typography. This if is the definitive solution of problems of communication between author and designer, moreover handwriting blends so good with illustrations that are drawn with the same stroke as the text:

refill pencil for flat leads

some tools on my table

this knife is the secret of the fine lines in renaissance wood-cuts (home made: spring steel ground and tempered)

Best regards, Yours, Gerrit

Elegant, crisp handwriting by Gerrit Noordzij, one of the best calligraphers and teachers of lettering in Holland

bottles of ink and paper. Every man can be an artist in his hand-writing.

Handwriting can be approached in two different ways with two different but overlapping aims. It can be approached and practised as a consciously artistic craft so that a note to a friend might become a minor work of art; or handwriting might be thought of simply as a tool of communication.

Of course all writing is intended for communication and, whether the aim is 'artistic' or purely utilitarian, legibility is of prime importance.

Writing may also be thought of as visible speech and the rules that govern articulation and audibility apply to writing in its different way. If in speech a speaker is slovenly and the listener cannot hear distinctly what is being said he can be asked to repeat it more intelligibly. Not so with a written letter. If the characters are ill formed and not clearly distinguished one from another the reader can only guess at the meaning. Sometimes u's and n's can be confused and r and v can look almost alike even from the hand of a conscientious italic hand writer. That may not often be serious to English readers, but if you need to write to people in different countries, as I do, using a different language and even a different alphabet you need to be very careful about the formation of letters that might be misunderstood in their context.

So it must be repeated that the first guiding principle in all writing is legibility. Even if, after competence has been acquired, sheer exhuberance or a desire to be decorative leads to flourishes or other ornamental features, legibility is still the prime quality.

Most peoples 'hands' are conditioned by how writing was taught to them at school, so it is argued that a beginning must be made in the schools. But teachers can only teach what they know and that often means what *they* were taught. So there was a need for a supply of good scribes to teach teachers. Edward Johnston at the Central School of Arts and Crafts and then at the Royal College of Art began to train first-class penmen who were to be an influence for good. Graily Hewitt with his books *Handwriting—Everyman's Craft* and *Lettering*, Percy Smith, M. C. Oliver, Rosemary Ratcliffe, Margaret Alexander and many others carried on the tradition.

But the R.C.A. between the wars had tended to become virtually

Lieber John,
heute mache ich Dir den Spaß, mein
handschriftliches Bild zu verändern.

Lieber John,
heute mache ich Dir den Spaß, mein
handschriftliches Bild zu verändern.

Lieber John,
heute mache ich Dir den Spaß, mein
handschriftliches Bild zu verändern.

Lieber John,
heute mache ich Dir den Spaß, mein
handschriftliches Bild zu verändern.

Analog zur Musik ist die Skala unserer
Ausdrucksmöglichkeiten in der persönlichen
Handschrift derart vielfältig, daß man auch
visuell die Kunst der Fuge darstellen und
nachempfinden kann.

Zukunftsmusik? Dein Karlgeorg.

A few 'hands' from the hand of Karlgeorg Hoefer, one of Germany's best letterer-calligraphers

a training college for teachers of art. The headmaster of almost every art school in the country was an ARCA (Associate of the Royal College of Art) and so were most of the staff. Like tends to appoint like. So most of them had, to some degree, been influenced by Edward Johnston, a magnetic teacher, and believed that Johnston's Foundation Hand should be taught to all—not only to art students who may become professional scribes or letterers but also to student teachers whose aim was not to produce professional scribes but simply to teach children to write clearly. The methods and models for the one are not necessarily right for the other.

Some people thought, and still do, that the Foundational models appropriate for a trainee professional do not suit young children.

As long ago as 1899 M. M. Bridges published *A New Handwriting for Teachers*, which proposed a humanistic rather than a copper-plate style which was the norm in Victorian times. Marion Richardson in 1935 published the Dudley Writing Cards which aimed at interesting very young children. A form of basic letter called 'print script' was developed, which many children are still taught.

But some of the methods (or habits) devised for children affected some teachers, and I speak from personal observation. For example, one way of helping children to space words evenly was for the child to put its finger or thumb between each word. A child's finger is small and the letters comparatively large so the space was not unreasonable. But I knew the headmaster of an infants' school whose own handwriting has the width of his thumb between each word so that the page seems sprinkled with words falling in a random fashion broken here and there by a wide vertical channel of plain paper where thumb width spaces fall below one another.

Many books and cards have been published advocating italic writing based on 16th century hands as the best model on which to form a legible script suitable for twentieth century use. Probably the best of these is Alfred Fairbank's *A Handwriting Manual* and his *Beacon Writing*. His form of letter and the method of acquiring its fluent application can hardly be bettered and his King Penguin, *A Book of Scripts*, is a first-rate, reasonably priced, anthology of fine writing from Roman times to the twentieth century.

Meetings. So habe ich – beinahe zu
fällig – im Klingspor-Museum den
gesamten dort liegenden Nachlaß
Rudolf Kochs zu sehen bekommen:
ein Erlebnis von seltener Eindrück-
lichkeit! Auch einen großen Teil des
Schneidler-Nachlasses habe ich mir
ansehen dürfen.

Solltest Du einmal statt in
China und Japan in der Schweiz
reisen, so bist Du jederzeit bei uns
willkommen!

Herzlich Dein

Jost Hochuli

Part of a letter by Jost Hochuli, one of Switzerland's best calligraphers and
teachers of lettering.

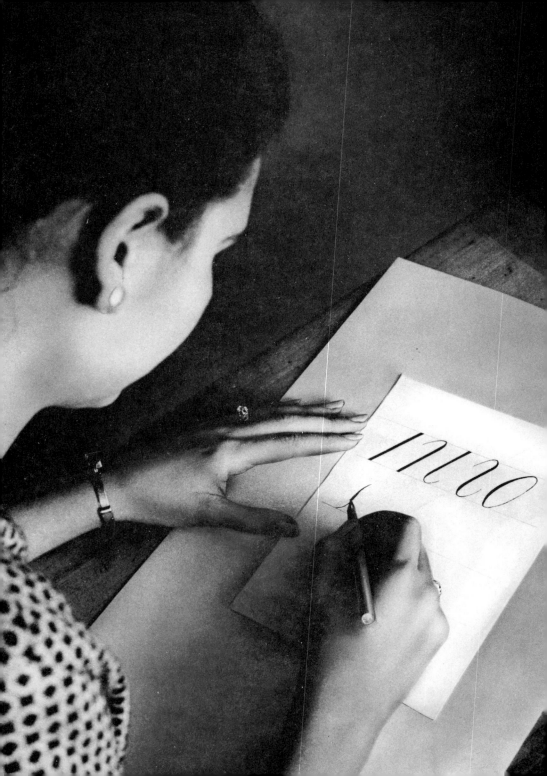

THE CRAFT OF

Script

New Year Greeting by Leonid Pronenko, a talented calligrapher who teaches at Krasnodar University, N.E. of the Black Sea.

THE CRAFT OF *Script*

The word 'script' is often used to denote a wide range of letter-forms that may be thin and spidery on the one hand or thick, chunky, and bold on the other. But in this book 'script' is used to signify the form of letter called copperplate. The term copper-plate is a logical description of this letter, which was developed during the sixteenth century, and from about A.D. 1600 a large number of instruction or 'copy-books' were published, the plates for which were engraved on copper. The influence of the graver on the shapes of the letters was considerable; and it should be remembered when studying the astonishing virtuosity of the seventeenth- and eighteenth-century writing masters that the fine-ness of the hair-lines, the sweetness of the curves, and the brilliance of the shading is as much the outcome of the graver as the pen.

The pen-men were a proud breed as is revealed in the titles of some of their copy-books which were as formal and elegant in their language as in the manner of their execution. *The Pen's Excellencie*; *The Pen's Transcendancy*; *A Delightful Recreation*; *The Penman's Paradise*; *The Universal Penman*; *Penmanship in its Utmost Beauty and Extent* are a few abbreviated titles. The following are the texts of two title-pages which demonstrate the verbal felicity

of these writing masters and also reflect the social custom of apprentices or pupils living with their masters: *A Delightful Recreation | for the Industrious | A Copy Book of Plain and Practical Writing | after the most Modish manner yet extant, with variety of Ornamt | by Command of Hand, | Invented and Performed by William Brooks, W.M. | at the corner of Hayes Court the upper end of Gerrard Street | near Newport Market in St Annes, Westminster. | Sold by the Author.* The other is *Round Text | A New Copy Book | by George Bickham | At Brentford-End, Middlesex | With whom Youth may Board and Learn Writing etc. | Likewise Drawing & Engraving all sorts of Works | on Copper Plates.*

The reader is recommended to study the old copy-books (a few of which are listed in the Bibliography) which can be seen in the Libraries of the British Museum and Victoria and Albert Museum. *The Universal Penman* is available in facsimile, published by Dover Publications (Constable) at a reasonable price.

Tools and Materials. The chief tool for writing script is, of course, the pointed, flexible pen—but a large amount of copperplate script produced for commercial purposes today is done with a brush. The early writing masters used a quill, and their copy-books give detailed instruction on the cutting of quills. These were later superseded by steel pens such as are used today. Excellent fountain pens are now available for copperplate writing.

Most of the writing for this book was done with Geo. W. Hughes' 'Peacemaker' pen No. 355F, but much preliminary experimental work was done with an Osmiroid and an Ester-brook fountain pen. Both of these pens are admirable and will produce fine copperplate handwriting for personal letters and the like. But a fountain pen will not work with waterproof Indian ink which is desirable for reproduction, and therefore a nib in an ordinary penholder was used.

Because of the great slope of script writing a swan-neck pen was invented as illustrated on page 135, which was intended to make writing easier. But there is little evidence that this is so, and it is not recommended.

There are large numbers of pointed flexible pens available, and it is best to try a number and choose the one that suits the purpose

best. Sometimes a large stiffish pen is best; on other occasions a small finely pointed very flexible nib is more appropriate.

A ruling pen is helpful for making straight stems of large letters. But care must be taken to avoid a noticeable join where the ruled line meets the freehand line of the curves.

Brushes should be good, springy sable brushes—sizes 1 to 4 being a reasonable range. A small one should be kept exclusively for the use of process white for touching up; and have a small water-pot for use with white only. Indian ink is inclined to spoil brushes—so always wash out brushes with soap and water (preferably warm) immediately after use.

A good bond paper is advisable for 'roughs' (and even for finished work for reproduction if it is really white and smooth), but good Commercial Art Board, Bristol Board, or Fashion Board is best for finished work, particularly if blocks are to be made.

Guide lines are made with an H or F pencil. Roughs are done with an HB, which is also used for scribbling on the back of the tracing paper. An H or 2H is used for transferring the drawing to the Commercial Board from the tracing paper.

Non-waterproof ink may be used for practice and roughs, but for finished work that will be passed on to the blockmaker or printer fixed or waterproof Indian ink is to be preferred. Mandarin Black was used for this book.

A pen-wiper (a piece of old cotton shirt or other absorbent but fluff-less material) is most important. Fixed Indian ink leaves a gummy deposit on the pen which must be wiped clean at almost every filling: great care must be taken to charge the pen with the right amount of ink—too much blots easily and fine lines are impossible; too little may dry up in the middle of a stroke.

Posture. The writer should sit on a chair that is neither so high that the feet do not rest comfortably with the heels on the floor, nor so low that the body tends to lean back. The desk, or rather the drawing-board on the desk, should be sloping and at a height so that the forearm can rest upon it without the body leaning forward unduly and not so high that the shoulders are lifted when the arm rests on the board. It is well worth the time and trouble

[135]

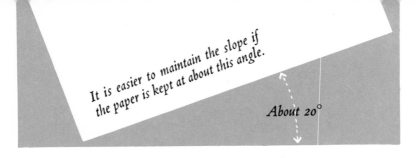

It is easier to maintain the slope if the paper is kept at about this angle.

About 20°

of arranging chair and desk height so that the writer is comfortable, relaxed, and able to move the right arm freely.

The paper or Commercial Board is placed on the drawing-board at an angle to the body rather than parallel to it as would be natural when writing traditional italic. The bottom edge of the paper about 20° from the horizontal is satisfactory as in the diagram above. This enables the pen to be kept at a normal angle in relation to the body (pointing over the right shoulder and in line with the forearm), but for the stems of the writing to be at a sharper angle with the writing-line than is customary with ordinary handwriting. A good angle is 60°, which has the advantage of being easy to achieve with a standard set-square; but more upright writing can be satisfactory and a sharper angle of about 54° is often very effective. The angle should be chosen to be appropriate to the situation.

The pen should be held between the thumb and index finger and supported by the tip of the middle finger. The whole hand rests lightly on the tips of the third and little fingers. The fleshy part of the side of the hand should barely touch the paper. This allows the maximum freedom of movement. It is helpful to think of writing as being done from the shoulder rather than from the wrist or fingers only. When making large letters the whole arm will certainly have to move from the shoulder.

After studying the diagrams on pages 137–142, practise the simpler basic strokes. The grid on page 143 may be used as a guide. Place bond paper (Spicer's Plus Fabric is excellent) over this grid and write as freely as possible; the printed lines of the grid will show through sufficiently to keep lines horizontal and letters at a constant angle. If a larger or smaller size of letter is desired another grid can be made easily by ruling another sheet of paper with horizontals and diagonals the required distance apart.

As with all forms of writing or lettering rhythm and consistency are qualities which should be always in mind. There are no rigid rules as to the number of stem-widths in the height of a letter or in its width. The governing principle is legibility with

(continued on page 147)

Capital letters are usually about the same height as ascenders, but they may be less without loss of grace and higher without affectation.

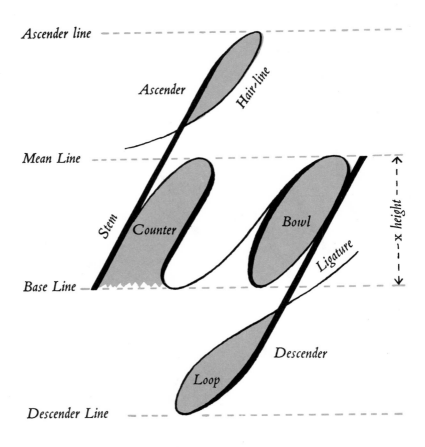

The space between lines, that is, the space between the base-line and the mean-line of the line below, is known as the interlinear channel. This should be at least two x heights.

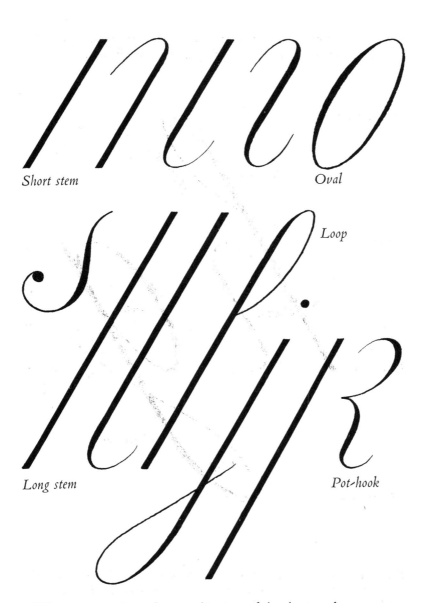

Short stem

Oval

Loop

Long stem

Pot-hook

All letters are made up from combinations of the above strokes.

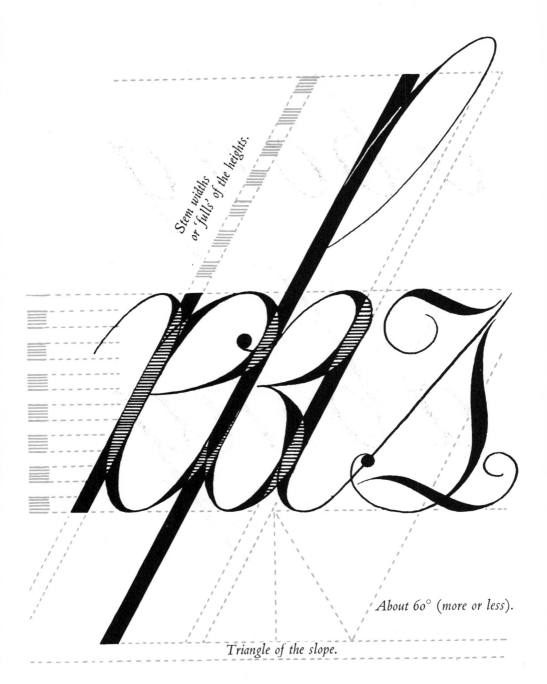

Stem widths or 'fulls' of the heights.

About 60° (more or less).

Triangle of the slope.

The oval counters of lower-case a, b, c, d, g, o, p, q should be kept as equal in shape and size as possible. See below.

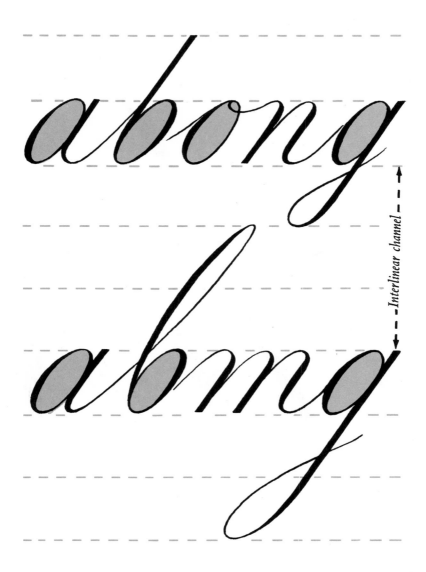

TOP *The ascenders and descenders are one x height each.*
BOTTOM *The ascenders and descenders are two x heights.*

Where letters are joined by a hair-line connecting the bottom of one letter with the top of the following letter aim at making the curve above and below the centre line similar, and the same distance from the stems on each side. The shapes enclosed will therefore be similar and preserve the even rhythm of the letters as shown on this page.

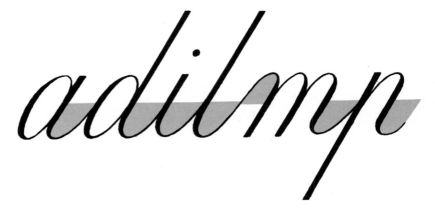

This aim at uniformity of enclosed shapes (counters) applies to all letters having a similar upswinging hair-line following a stem. These letters are a, d, h, i, k, l, m, n, p, t, u. The diagram on this page emphasises the uniformity of the shapes and angles of the ligatures in these letters.

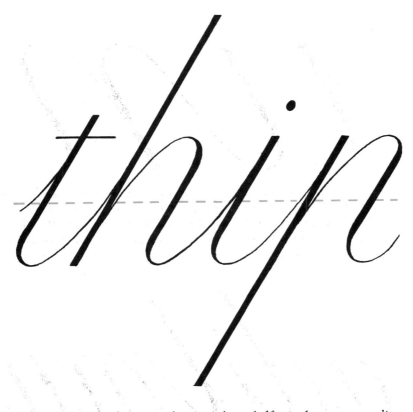

Endeavour to join letters at about, or above, half-way between mean-line and base-line. In a tightly spaced line it may be necessary to join lower down—but do not join at a point lower than a third of the height of a letter *i*, otherwise the characteristic elegance of copperplate script will be lost.

Imagine a small circle as the pen swings upward and so avoid the unsightly point.

DO NOT turn from stem to hair-line as sharply as this.

Grid over which to lay 'bond' paper for practising. The horizontals give base-line, mean-line, etc., while the diagonals aid consistency of slope.

Try writing these simple strokes freely and rhythmically.

Join these strokes into a continuous series of arches.

Make a similar rhythmical series with the arch at the foot

followed by a combination of the two which make n, u, m, w.

Repeat often—but stop before being bored.

C O O O O O O O

The oval may be made with one or two strokes.

C C e e e e e c c c

It should be practised assiduously and freely.

a a a a a a a a a

Combine it with a short or long stem to form a,

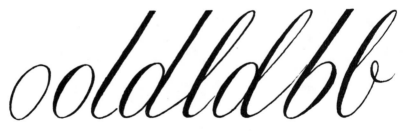

o o l d l d b b

b, or d. After some practice add a loop to b, d, and g.

g g g p p q g

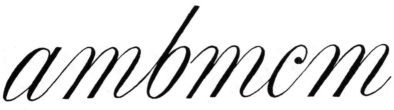

ambmcmcm

The m is perhaps the most important letter because it

emimomu

sets the rhythm. Alternate each letter of the alphabet

mrmrvm

with an m, keeping all letters a regular distance apart,

tmumvn

all stems the same thickness and length, all arches

muwmyn

well rounded and joins smooth and flowing.

mxmzu

elegance as a good second. But it is usually better to err on the side of slenderness rather than corpulence. Bold, fat scripts can be interesting and effective (the hair-lines should be kept thin, but copperplate is probably as its best when the stems are thin and the hair-lines fine. A satisfactory proportion is that given on page 139 where the stem-widths (or fulls as they were called in the old copy-books) are clearly indicated.

The examples on pages 150–180 show three different weights, three degrees of elaboration, and the effect of reversal from black to white. For white lettering on a solid ground it is best to draw in black and white and arrange for the reversal to be done by the blockmaker (or printer if reproduction is by photo-lithography as in this book). The area of solid background is defined by a thin black line.

When writing with pen or brush, whenever possible draw the pen down towards the body rather than push it away. Fine hair-lines may be made as up-strokes, but care must be taken not to put much pressure on the nib, otherwise it will splutter. In order to allow the pen to move down towards the body, the paper may be turned; indeed, in many of the curves and flourishes it is quite necessary to turn the paper to complete them. Turning the design upside down frequently reveals faults of spacing and particularly flaws in curves. An apparently flowing curve can prove to be full of awkward angles when turned upside down. It is therefore wise to make a rough of any important piece of lettering so that all the corrections can be made at the rough stage—only the final refined forms being traced for transfer to board.

Small letters or minuscules (what printers call lower-case) comprise the bulk of letters in any style, and it is therefore most important to master these. It is perhaps even more important with script than with other styles because words in script capitals are not legible and are therefore rarely seen. Capitals are almost invariably combined with lower-case. Though capitals can look very dashing parading their curves with the *bravura* of show-girls, the solid business of conveying the message is by means of lower-case.

Study, and preferably copy, the diagrams carefully. Note the significance of the oval counter which is contained in a, b, c, d,

(continued on page 163)

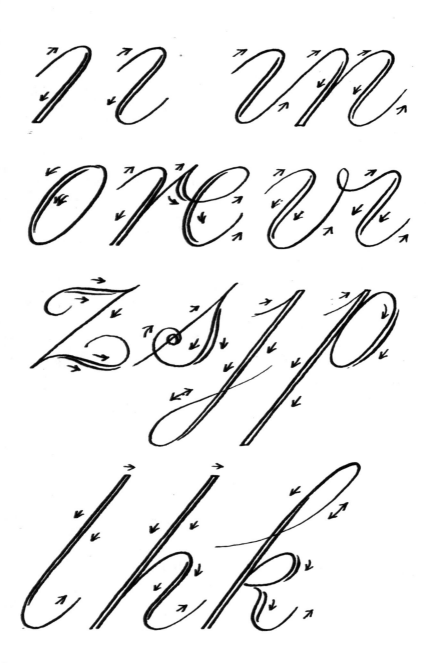

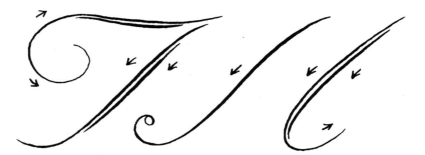

The size of the letter affects the direction of stroke. The hair-lines of small letters may be made with an upward stroke, but in large letters the pen is liable to splutter on up-strokes.

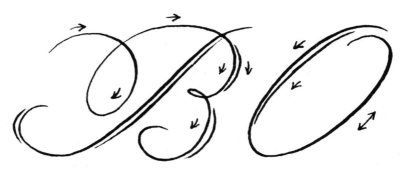

It is therefore often better to make large letters with down-strokes. The double-headed arrow indicates that the stroke may be made up or down.

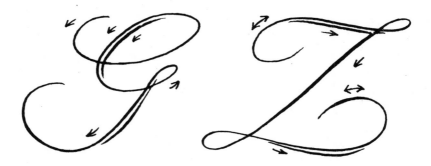

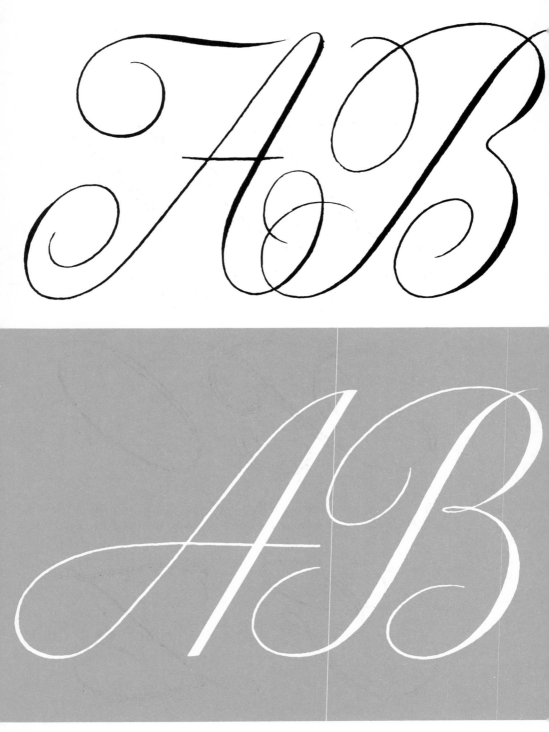

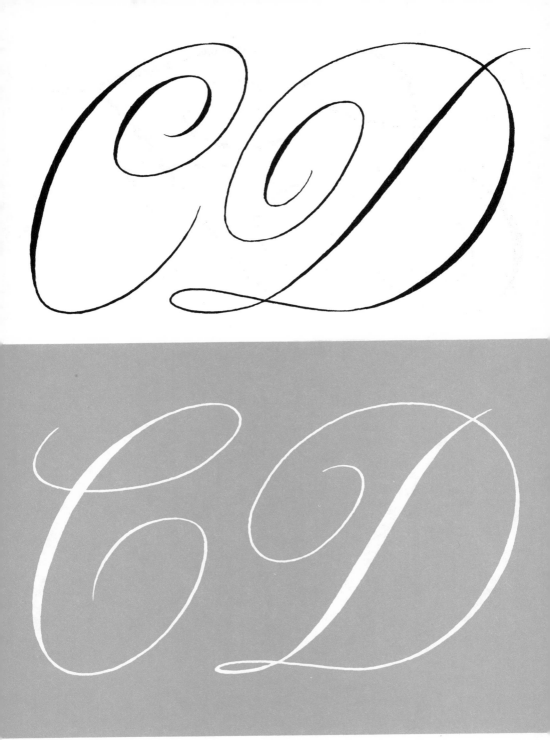

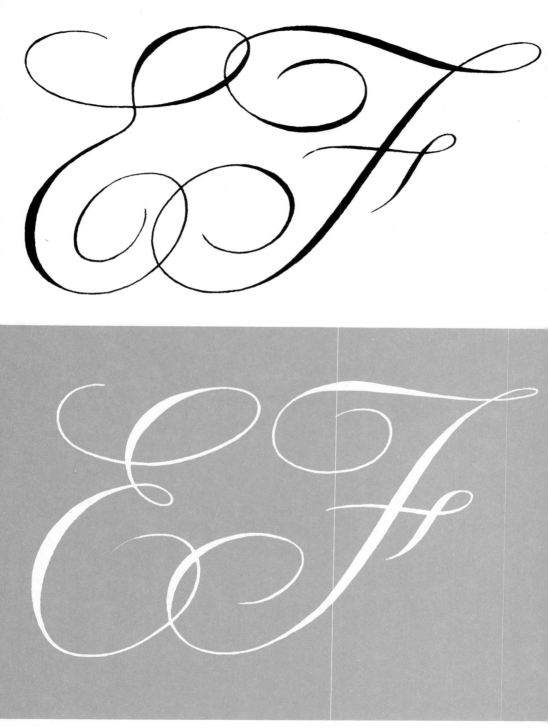

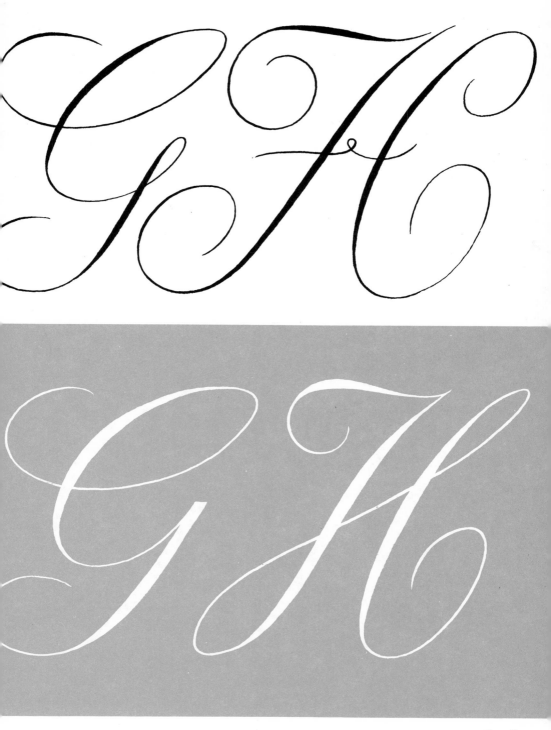

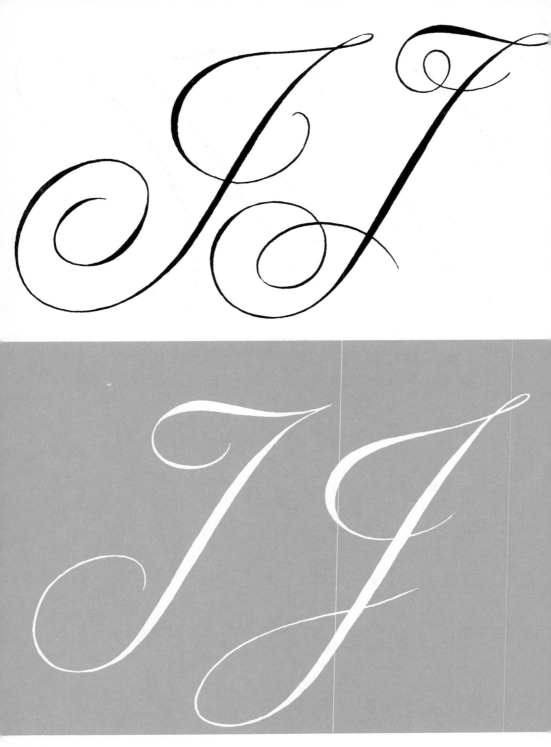

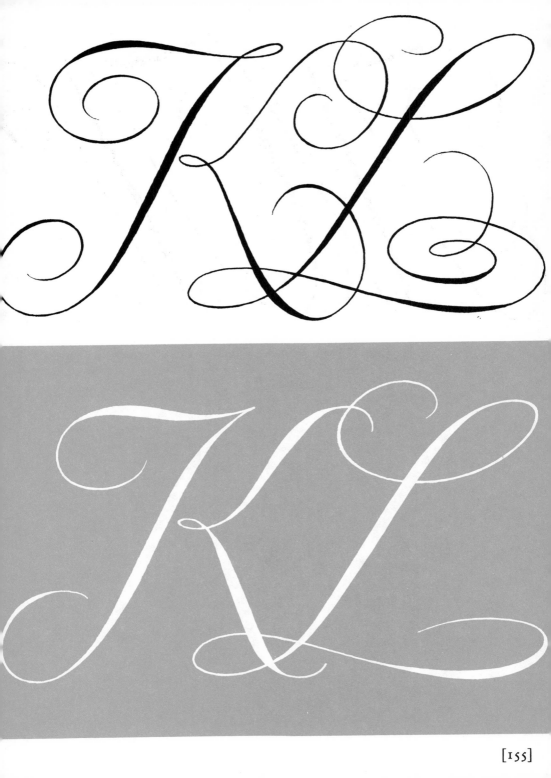

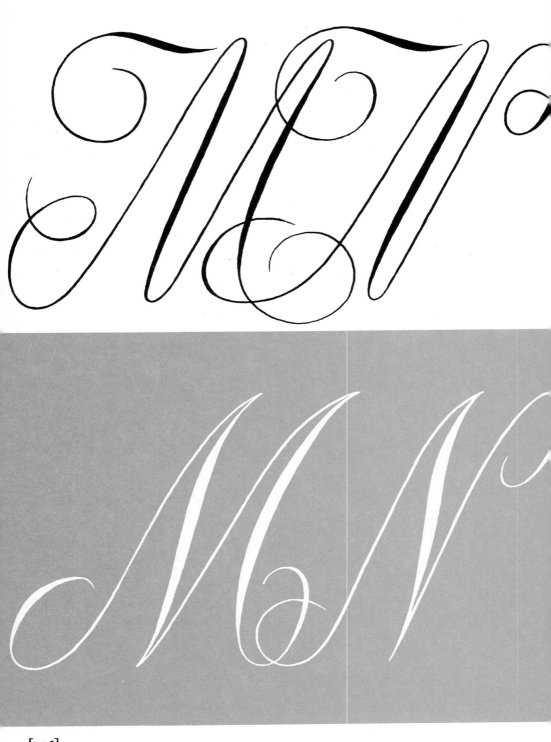

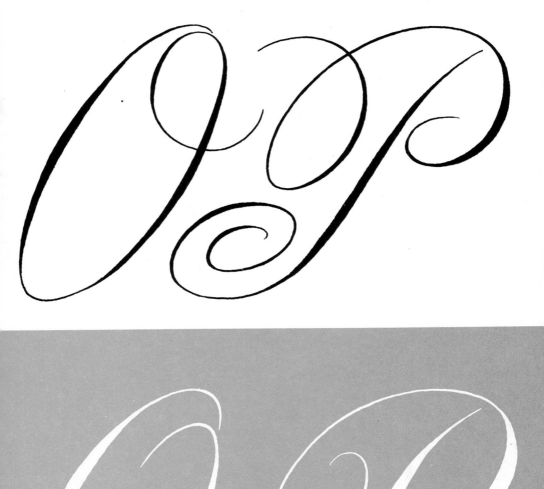

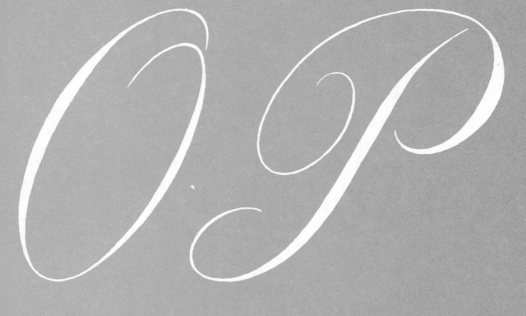

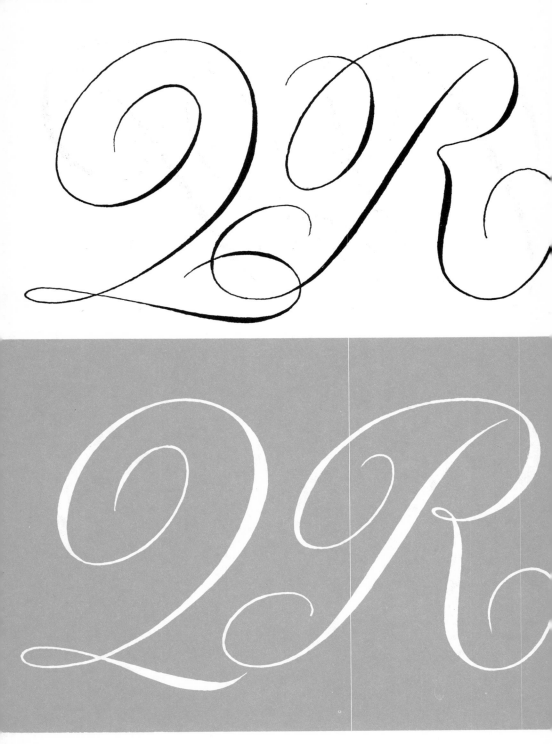

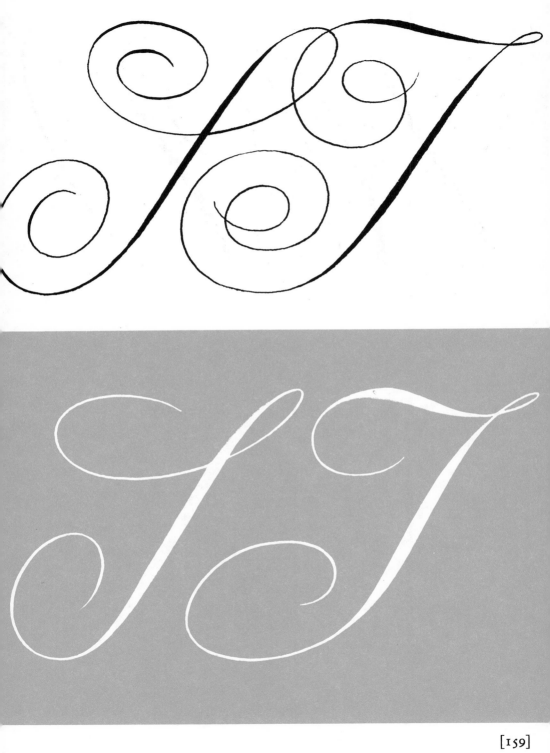

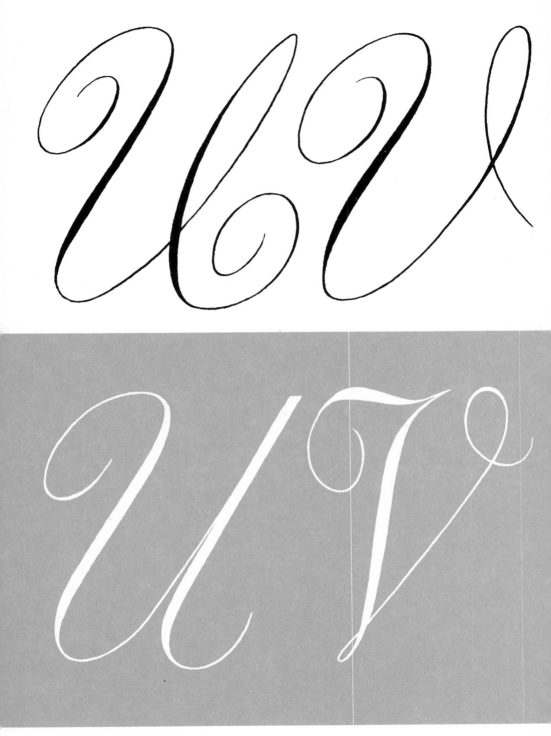

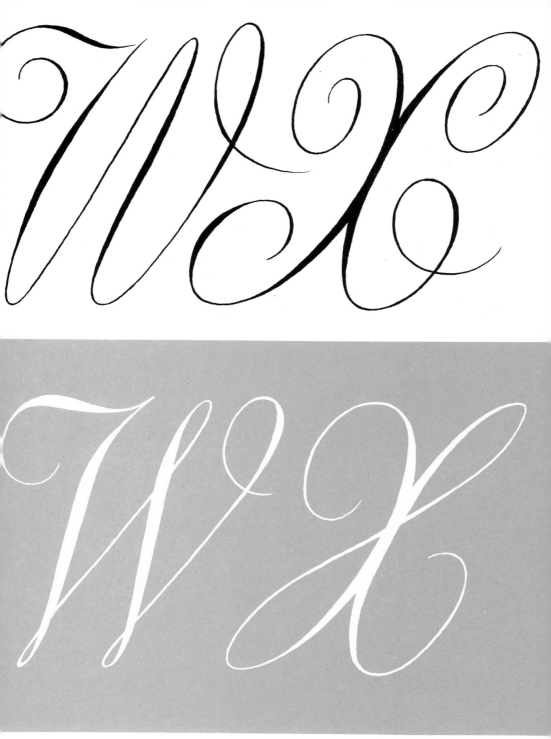

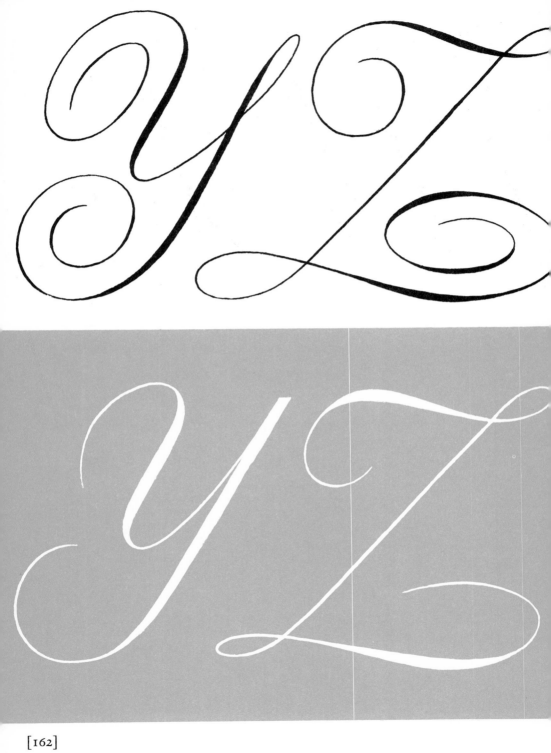

e, g, o, p, q. Aim at getting these the same size and shape (page 140). The point of maximum stress is below the centre.

Ligatures should join the stem of the following letter at or above the half-way line (page 142) and the counters enclosed by the 'pot-hooks' should be as near uniform as possible. Avoid a sharp angle where the stem reaches the base-line and swings up to join the next letter. Make sure these shapes are kept well rounded by imagining a small circle at the bottom of the stem. Make the outer stroke first, going round the imaginary circle and following through into the next letter in one stroke. Add the thickness of the stem next, taking care not to thicken the hair-line too much where it touches the base-line.

Follow through from one letter to another as often as possible. It is clearly necessary to lift the pen from time to time, but pen-lifts should be as few as is consistent with ease and accuracy of writing.

Keep the stems of letters straight and firm—particularly the first stroke of u, v, w, y, and the last stroke of h, n, m, and the alternative version of p. These strokes easily degenerate into a limp double curve instead of being a straight stroke with a curve at either end.

Try to keep all stems and accents of curved letters a uniform distance apart. The space between words should be about the space of n or o.

The length of ascenders and descenders is governed by circumstances and personal taste. If the amount of space is small and legibility is paramount ascenders and descenders may be shortened. The descenders may be shortened more than ascenders without loss of legibility or dignity. If there is plenty of space, ascenders may be two, three, or even more times the x height; and descenders, too, may be extended, perhaps with a flourish into the space at one's disposal.

efgh

efgh

l m n

rstu

rstu

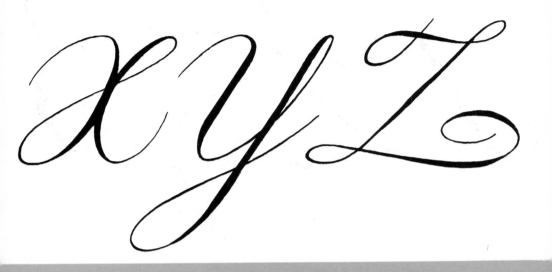

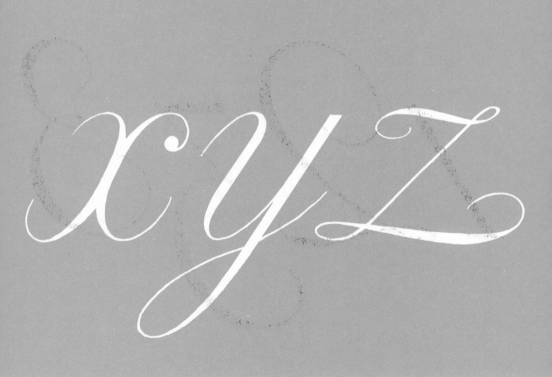

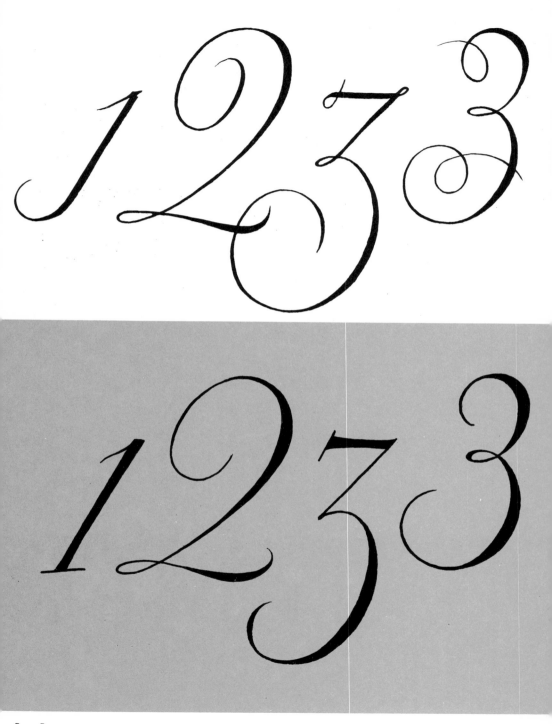

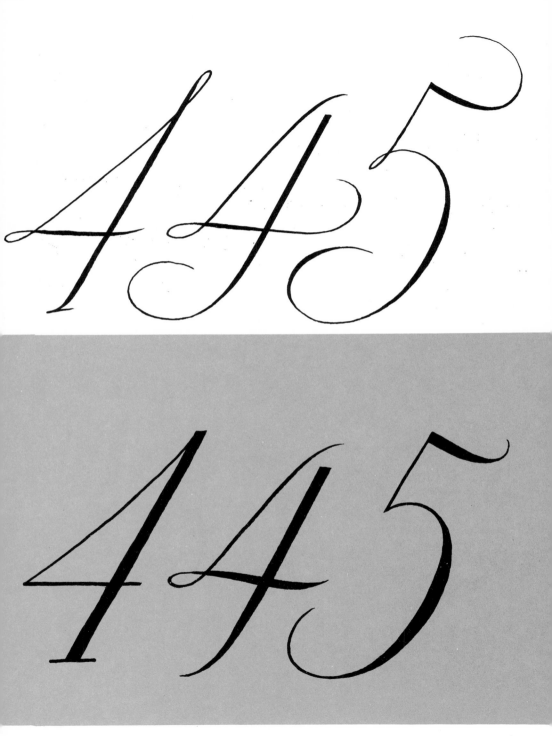

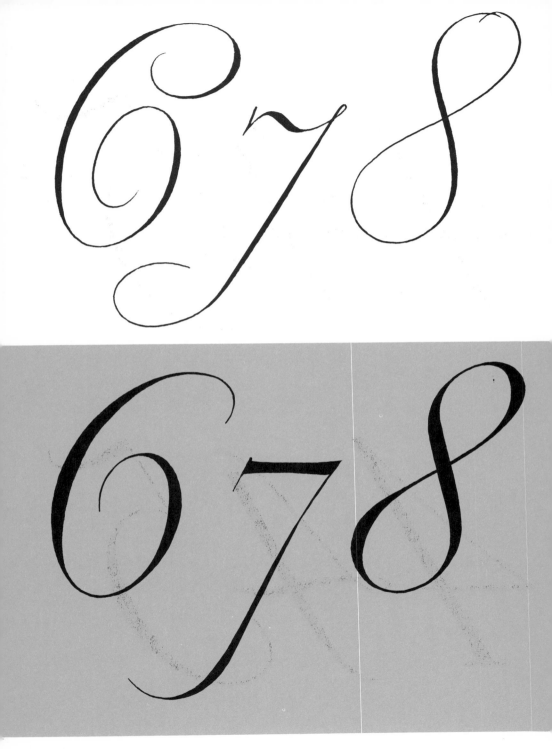

890?

890?

A B C

G H I J

N O P

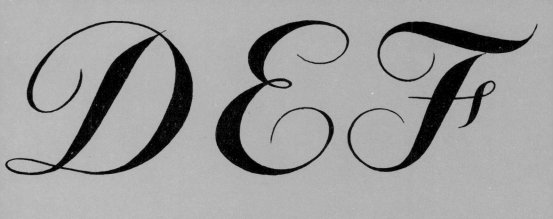

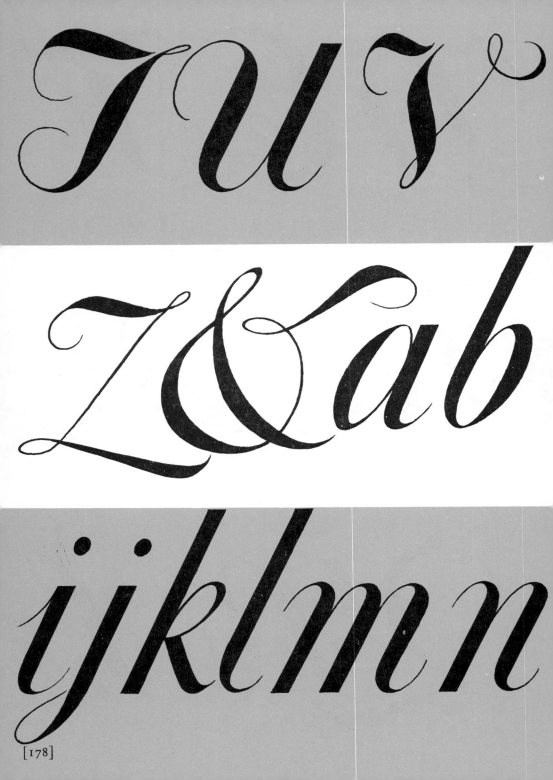

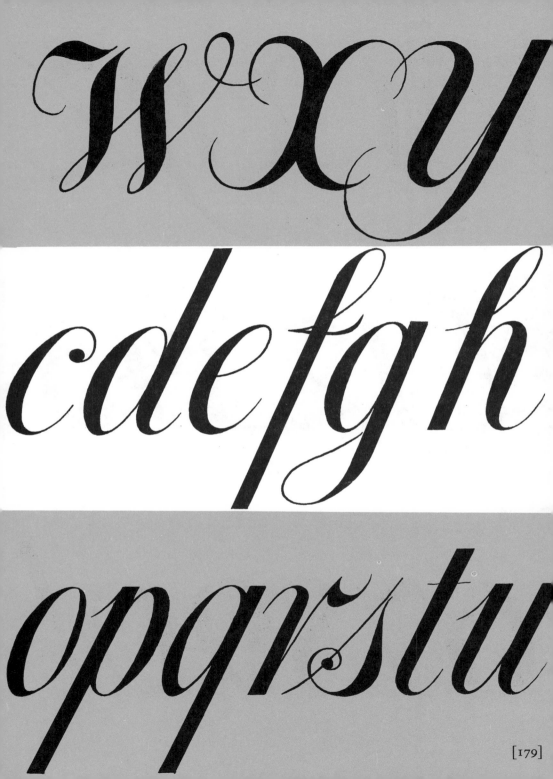

VWXYZ

L12345

67890!

flourishing

Flourishing is perhaps to the layman or beginner the most conspicuous characteristic of script. Script lends itself to grandiloquent displays of virtuosity with the pen. At its best flourishing is magnificent; at its worst it is abominable. Used with taste, flourishes can be extremely decorative and the simpler versions have a formal austerity and quality of abstract design that commands admiration. But it should be remembered that flourishing, like other forms of decoration or embellishment, is not an end in itself but a kind of ceremonial extension of the function of conveying a message. The word or words and their meaning should therefore be kept clearly in mind and the flourishes designed to enhance—not to obscure the words.

Nevertheless there are occasions when decoration or even fantasy is appropriate and flourishing offers great opportunity for invention and the exercise of calligraphic imagination. Some of the seventeenth- and eighteenth-century writing masters were not only virtuosi of purely abstract flourishes but ingenious devisers of fish, birds, horses, nude humans, knights in armour, cherubs, angels, fabulous beasts—all built out of pen-strokes spun with the slickness of a circus performer or the fastidious fancy of a lace-maker.

After practising the basic strokes and copying a few flourishes try inventing simple border designs. Avoid awkward angles and do not allow thick strokes to cross one another. A line crossing a thick stroke should be thin. After experimenting with capital letters by extending the strokes, do the same thing with the ascenders and descenders of lower-case letters.

The Spiral The Oval The Circle

The Swelled Curve

An enormous variety of patterns can be achieved with variations and combinations of the above four forms. A comma is often added at the end of the spiral. Practise the basic strokes which when repeated make a pattern in themselves. Other shapes and patterns will suggest themselves.

Roun

A New

By George

At Brentford-En

With whom Youth may B

Likewife Drawing, & Engra

G. Bickham scr: et sculp.

d-Text

opy-Book

Bickham &c.

MIDDLESEX.

rd, and Learn Writing, &c.

ing all sorts of Works on Copper Plates.

Title-page of an eighteenth-century copy-book.

SCRIPT TYPES

The taste for copperplate engraving and lettering reached a point in the eighteenth century when the whole of a book of about 300 pages was engraved on copper plates (Quinti Horatii Flacci, Opera, 1733). This was an impressive *tour de force* by John Pine, but the absurdity of engraving all the small text on copper did not survive. The taste for copperplate script letter for 'display' and ephemera did—particularly for visiting cards.

The fashion for copperplate lettering led the typefounder to produce types that so closely resembled engraving that the layman might well mistake the letterpress version for engraving. Some of the nineteenth-century copperplate script types survive, and it is remarkable that in spite of the vogue for sans-serif lettering and severe unornamented typography, script types and lettering have persisted and a number of new copperplate scripts have been produced since the 1939–45 war, particularly by continental typefoundries. There have also been many types cut based on brush scripts, but we are here concerned only with the copperplate tradition. The specimens shown, though not large in size, should provide the letterer with some inspiration.

ARISTON was cut by Berthold (Germany) between 1933 and 1936. The descenders are short but it is very legible.

BERNHARD CURSIVE or MADONNA, also German (Bauer), was cut in 1925. Later it was available from Stephenson Blake.

CALLIGRAPHIQUES is a French (Deberny Peignot) version of the English copperplate tradition.

COPPERPLATE BOLD is English (Stephenson Blake), 1953. The lower-case p and q are a little out of harmony with the other letters.

GRAPHIC SCRIPT is another German (Bauer) type, 1934, which is elegant and shows real feeling for copperplate.

INVITATION SCRIPT is a sound English traditional type (Stephenson Blake).

JULIET comes from Italy (Nebiolo), 1955. The capitals are highly involuted—but it has charm.

MARINA and PALACE SCRIPT—both from Stephenson Blake —are good.

ABCDEFGHIJKLMNOPQRSTU
abcdefghijklmnopqrstuvwxyz

ARISTON LIGHT

ABCDEFGHIJKLMNOPQRST
abcdefghijklmnopqrstuvwxyz 1234567890

ARISTON MEDIUM

ABCDEFGHIJKLMNOPQ
RSTUVWXYZ abcdefghijklmnopqrstu

vwxyz 1234567890

BERNHARD CURSIVE

ABCDEFGHIJKLMNOPQ
RSTUVWXYZ abcdefghijklmnopqrst

uvwxyz 1234567890

BERNHARD CURSIVE BOLD

ABCDEFGHIJKLMM
NOPQRSTUVWXYZŒ

abbcdeeffgghijjkkllmnopp

qqrrsstt uvwxyyzz çœœon

12345 & 67890

CALLIGRAPHIQUES

A B C D E F G H I J K L M N O
P Q R S T U V W X Y Z abcdefg
hijklmnopqrstuvwxyz 1234567890

COPPERPLATE BOLD

A B C D E F G H I J K L
M M N O P Q 2 R S T U V W
X Y Z abcdefghijklmnopqrstuvwxyz e h l r s t z
1234567890

GRAPHIC SCRIPT

A A B C D E F F G G H H I
J K K L L M M N N O P Q 2 R
S S T U V W X Y Z 1234567890
abcdefghijklmnopqrstuvwxyz e h l r s t z

GRAPHIC SCRIPT BOLD

A B C D E F G H I J K L M N O P Q
R S T U V W X Y Z
abcdefghijklmnopqrstuvwxyz 1234567890

INVITATION SCRIPT